LEGENDARY LOCALS

OF

ANN ARE

MICHIGAN

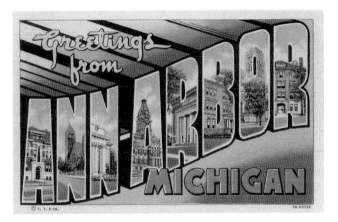

In Memoriam

Wystan Auden Stevens's wife, Catharine, used to joke that, though she was married to him, Wystan was really married to Ann Arbor. Wystan was born in Ann Arbor and was named after W.H. Auden, the 1941–1942 poet-in-residence at the University of Michigan. Stevens's father was an English professor and greatly admired Auden. Auden reciprocated not only by writing a poem, "Mundus et Infans," about the expected child, but also by serving as godfather to Wystan. Stevens lived his entire life in Ann Arbor. As a University of Michigan student, he originally studied art but soon succumbed to the siren call of history. For 30 years, Wystan led autumn tours of Forest Hills Cemetery, regaling his audience with stories about locals buried there. Wystan was a veritable fountain of local lore, and he loved to share his Ann Arbor knowledge with anyone and everyone. When we, the authors, were looking for Harvey Drouillard's last name, it was Wystan who knew it. At age 72, Wystan died in his sleep on July 26, 2015. Rest in Peace.

Page 1: Greetings from Ann Arbor, Michigan

Welcome to a diverse city that celebrates its connection of past and present and looks with confidence to its future. (Courtesy of the Bentley Historical Library.)

LEGENDARY LOCALS

OF

ANN ARBOR
MICHIGAN

SUSAN L. NENADIC AND
M. JOANNE NESBIT

LEGENDARY
LOCALS

Copyright © 2016 by Susan L. Nenadic and M. Joanne Nesbit
ISBN 978-1-4671-1684-8

Legendary Locals is an imprint of Arcadia Publishing
Charleston, South Carolina

Printed in the United States of America

Library of Congress Control Number: 2016942358

For all general information, please contact Arcadia Publishing:
Telephone 843-853-2070
Fax 843-853-0044
E-mail sales@arcadiapublishing.com
For customer service and orders:
Toll-Free 1-888-313-2665

Visit us on the Internet at www.arcadiapublishing.com

On the Front Cover: Clockwise from top left:
Shakey Jake Woods, musician and storyteller (Courtesy of Rachel Holmes; see page 62), Wystan Auden Stevens, Ann Arbor historian and Forest Hills Cemetery tour guide, (Courtesy of the Peter Yates Collection, Bentley Historical Library; see page 2), Eunice Burns, city council member and supporter of the first fair housing law in Michigan (Courtesy of Eunice Burns; see page 51), Peter Sparling, dance teacher at the University of Michigan and artistic director of the Peter Sparling Dance Company (Courtesy of the Bentley Historical Library; see page 115), Dr. Irene Hasenberg Butter, a Holocaust survivor and former professor at the University of Michigan (Courtesy of Irene Hasenberg Butter; see page 69), Jim Smith Sr. and Jim Smith Jr., operators of Washtenaw Dairy (Courtesy of Jim Smith Jr.; see page 99), Keith Hafner, owner of Keith Hafner's Karate School (Courtesy of Keith Hafner; see page 96), Dr. Elizabeth Crosby, the first woman to receive full professorship at the University of Michigan Medical School (Courtesy of the Bentley Historical Library; see page 21).

On the Back Cover: From left to right:
Canoers on Huron River, near Ann Arbor (Courtesy of the Bentley Historical Library), State Street, Ann Arbor (Courtesy of the Bentley Historical Library).

CONTENTS

INTRODUCTION

Ann Arbor is unique. It is the only city in the world named Ann Arbor. There is some disagreement as to exactly how that name was chosen, but there is little doubt that it is a fascinating place to live. Various factors make it so; however, even the most casual observer will spot a couple of elements that distinguishes Ann Arbor from neighboring towns—cultural and ethnic diversity. Surrounded by communities that are predominately Caucasian and Christian, Ann Arbor is a veritable quilt of ethnic, racial, and religious diversity. And it has been so throughout its history.

Several African American families came to Ann Arbor during the earliest years of settlement. Ephraim Williamson arrived in 1824, the year Ann Arbor was founded. His daughter Hannah was the first African American child born here in 1831. John and Thomas Freeman were not only barbers by trade but also leaders within the black community. Thomas was a delegate to the 1843 State Convention of the Colored Citizens of the State of Michigan. By 1860, more than 100 African Americans called Ann Arbor home. A century later, the number of African Americans had risen to almost 3,000. Charlie Thomas and Letty Wickliffe, in addition to Albert Wheeler and his wife, Emma, actively worked to promote and protect the area north of Kerrytown, which was where 80 percent of Ann Arbor's African Americans lived.

Next came the Germans. John Henry Mann was the first. He arrived in 1830 and opened a tannery. As late as the 1880s, almost half of Ann Arbor's population were of German descent, and one out of nine residents were German born. Their impact on the town's evolution cannot be overstated. They established businesses such as Eberbach's pharmacy, Allmendinger Organ Factory, and Hutzel's Plumbing, which sold paint and pipes. Philip Bach not only owned a retail business, but he also became the first mayor to have been born in Germany.

Some of the German immigrants were Jewish. Joseph Weil and his brothers arrived in 1845. Joseph was still in Ann Arbor in 1861 when, at age 84, he led the Washington's Birthday Parade. His son Jacob served as alderman in 1850 and 1860. Simon Guiterman operated a clothing store, and Charles Fantle had a dry goods business. Their small Jewish community selected a location just north of the original 40-acre University of Michigan (U-M) campus for their cemetery. That space today is a Holocaust memorial. Most of these early Jewish families left Ann Arbor. It was not until the early 20th century that the Jewish community grew to enough congregants to warrant the arrival of a rabbi and the establishment of Temple Beth Israel in 1940.

In addition, the University of Michigan attracted many Jewish students who were banned from attending the Ivy League schools. That is why author Arthur Miller chose University of Michigan. Ann Arbor's Hillel chapter is one of the largest and most active in the country. It produced Miller's very first play.

The Germans were followed quickly by immigrants from Ireland and Italy. Many Irish immigrants who settled in Ann Arbor were fleeing the potato famine in the 1840s. But some Irish, like tailor William O'Hara, leather dealer William McCreery, and attorney John Berry, immigrated before the famine occurred. The Irish brought Catholicism to the city. As early as 1831, a Detroit priest named Fr. Patrick O'Kelly came to minister to Ann Arbor Catholics. He was followed by Fr. Thomas Cullen, who guided his flock in the purchase of land near Division and Kingsley Street for a church. By 1868, they had purchased Ann Arbor's North School, where they opened a parochial school. Later in the century, the Italians joined the Irish. Today, the building, which houses Zingerman's Deli, was built by the Disderides, who were Italian immigrants.

In the 20th century, people came from Greece in sufficient numbers to build St. Nicholas Greek Orthodox Church. Many Asians, most affiliated with the university, brought their traditions. By 2005, more than 7,000 residents of the city were Asian. More recently, Ann Arbor has become home to natives of India and the Middle East.

Each group has added to the ambiance of Ann Arbor. When one walks around downtown, he or she will hear people speaking Japanese, Mandarin, Hindi, Arabic, German, French, and English. Residents and visitors can dine on international cuisine such as sushi, fattoush, and spanakopita. They can sit at the Blue Nile eating Ethiopian food or at Shalimar for Indian cuisine.

The diversity of the population is perhaps best witnessed not by the city's wide range of places to eat but by its places to worship. Within a population of slightly more than 116,000, one can find a wide variety of Protestant churches, including traditional congregations of Methodist, Presbyterian, and Lutherans. There are churches that attract specific ethnic populations. There are the Korean United Methodist and the Korean Presbyterian churches. Ann Arbor also offers churches for African American worshipers. There are two Roman Catholic churches and a Greek Orthodox congregation. One building on Packard Street is home to both an Episcopalian church and a Jewish synagogue. They have been sharing that facility for decades. Residents also can seek spiritual enlightenment at either a Zen or Tibetan Buddhist temple. For those who prefer Islam, there is a mosque. If none of those suits a person, he or she can try the First Unitarian Universalist Congregation of Ann Arbor or, perhaps, the Ann Arbor Friends Meeting.

Because Ann Arbor offers such a rich history and contemporary culture, it was difficult to limit the content of a book this size. There are so many interesting people. Some are well known thanks to previous publications and the Downtown Street Exhibit. We have tried, therefore, to focus on lesser-known townies whose contributions still influence the city and its residents.

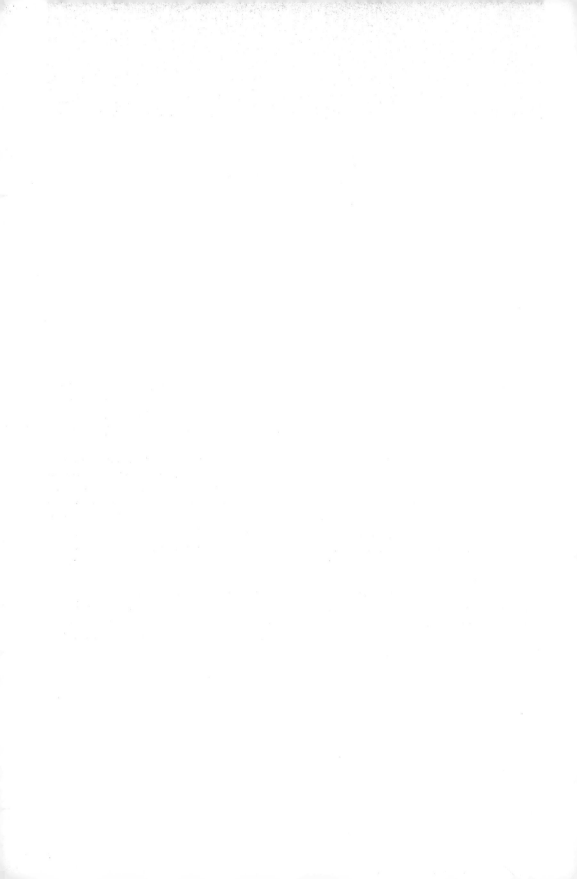

CHAPTER ONE

The River

The Huron River serves as the watershed for a huge swath of Southeastern Michigan. As it has been for towns throughout history, a river was the primary reason people settled in Ann Arbor. John Allen, one of the founders of Ann Arbor, extolled the Huron River in letters to friends back East and stated, "Our water is the purest . . . our river the most beautiful." Today's residents would surely agree with those sentiments.

When modern man first thinks of water, he thinks of drinking and washing. Those were important to settlers, too, but 19th-century pioneers quickly assessed the value of the Huron River in terms of producing power. One little boy, whose parents settled the area, asked his mother why she never made bread much anymore. Making bread required his father to travel all the way to Detroit to grind the grain into flour. So it is not surprising that the establishment of gristmills was on the top of early settlers' wish lists. Sawmills came in a close second, followed by textile and paper mills. Within two decades, dozens of mills lined the river through Ann Arbor taking advantage of the 297 million gallons of water that flow through the area daily and the power that water generates. In winter, the river offered ice that businesses cut and stored for use year-round.

As the hard work of early settlement days gave way to a more established lifestyle, residents began to appreciate the river for its beauty and for leisure-time activities. In winter, there was ice-skating. In warmer weather, walking, picnicking, fishing, and boating have become a significant part of the Ann Arbor scene. Today, there are opportunities galore. Water lovers can paddle the Argo Cascades, fish, or learn to practice yoga on a paddleboard.

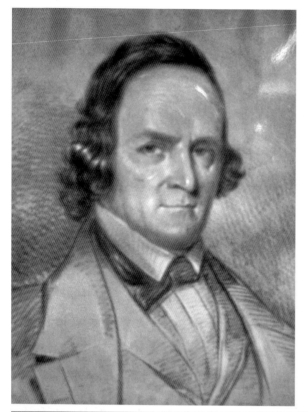

Perfect Spot

In 1824, when John Allen (drawn from life at left) and Elisha Rumsey began looking for land to buy, they had three major criteria. They wanted to find a place with good soil for farming. They also were looking for one of Michigan's "oak openings" so that farmers did not need to clear the forest before beginning to plant crops. Their final, and most important, criteria was water. As soon as they saw the Huron River, they were convinced. They hurried to Detroit to file their claim of one square mile of land that would become the city of Ann Arbor. Returning to their claim site, they set up camp near what is now Huron Street between Ashley and First Streets. Today, there is a sign marking that historic spot. It was a perfect place because it was next to the north-south tributary of the Huron River, which came to be called Allen Creek. (Courtesy of the Bentley Historical Library.)

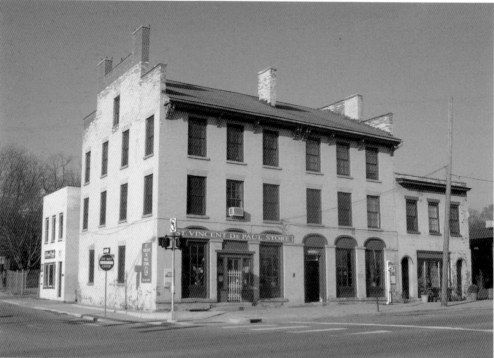

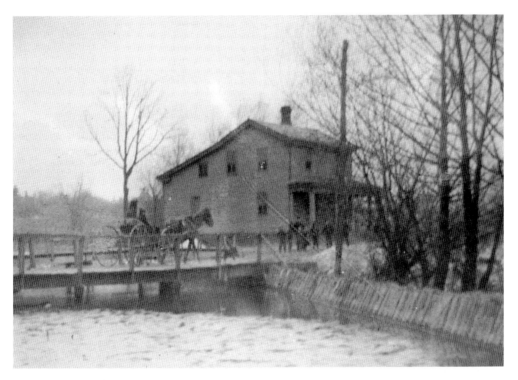

View from a Bridge

Sophia Pierce (née Monroe) was born in New York, but her family came to Ann Arbor in 1838. She married Nathan Pierce in 1847, and though she was the mother of five children, she was anything but the stereotypical housewife. Sophia was a prodigious writer who contributed articles to national magazines. In Ann Arbor, she was better known for her poetic column in the *Ann Arbor Courier*. "Ann Arbor in Slices" was a satirical series, no doubt inspired by a similar column in New York City. In one of her writings, she relates the story of how, one spring, a local church was using the Huron River for baptisms. Elegantly dressed men and women stood on the bridge watching. Suddenly, that bridge collapsed sending everyone into the river. The photograph is of a footbridge over the Huron River in 1894. It would have been similar to the one in Pierce's account. Pierce also founded, in 1870, the 5th Ward Decoration Society, for which she served as president. In addition, she quite possibly was the only female census enumerator in Michigan. She squeezed those jobs into her busy schedule as a "clairvoyant physician." (Courtesy of the Bentley Historical Library.)

Unrealized Dreams (OPPOSITE)

Today, few residents think of Ann Arbor as a divided city, but in the early 19th century, it was. Allen and Rumsey speculated in land, specifically the bluffs on the south side of Huron River. Anson Brown, another of Ann Arbor's earliest settlers, had a different idea. Today, Ann Arbor's oldest commercial building (pictured here) built by Brown sits east of the Broadway Bridge, which provides transportation over the Huron River. Behind that building at the crest of the hill is a blue house. These buildings belonged to Anson Brown. He also built a gristmill near where the Argo dam stands today. Brown, a native of New York, wanted his side of Huron River, dubbed "Lower Town," to become the center of Ann Arbor. In 1832, he managed to get the post office located there much to the chagrin of the "Upper Town" residents. But all of Brown's dreams came to naught because Brown died when a cholera epidemic swept through the area in the early 1830s. (Photograph by Susan L. Nenadic.)

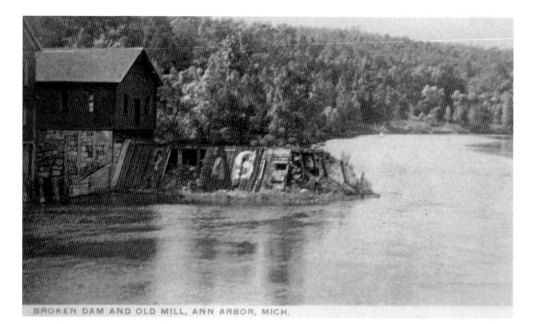

BROKEN DAM AND OLD MILL, ANN ARBOR, MICH.

Lengthy Lawsuit

Harvey Cornwell was born in Connecticut in 1820. He and his brothers Henry and Cornelius came to Ann Arbor in 1836. The brothers established a woolen mill in 1840. Harvey farmed until the California Gold Rush lured him west. He returned to Michigan in 1852 and invested in a paper mill and dam with his brothers. To power it, in 1885, they built a 12-foot-high and 170-foot-long dam. It produced plenty of power for the Cornwell brothers but ruined the Sinclair Mill and the Agricultural Works that were downstream. A lengthy lawsuit over water rights ensued. Finally, in 1892, the Michigan Supreme Court ordered the Cornwells to remove the dam. What remains of it today forms part of the pedestrian bridge to Barton-Oxbow Park. (Courtesy of the Bentley Historical Library.)

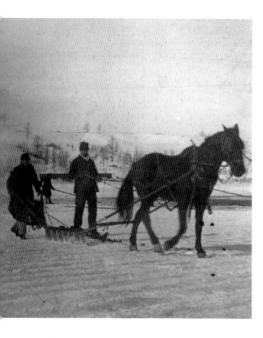

Cold Cuts

During the final three decades of the 19th century, the ice business became popular. When the river froze, men would plow the ice in order to cut it into movable pieces that could be stored in insulated sheds. Between 1872 and 1900, Michael Andreas had such a business. Another c. 1883 ice company began as the Hangsterfer Ice Company. In the latter case, such a business seems logical because the Hangsterfer family owned and operated a confectionery at the southeast corner of Main and Washington Streets. Jacob Hangsterfer began the business; his widow, Catherine, managed it after her husband's death in 1873. Eventually, her son A. Frank Hangsterfer assumed ownership. In fact, Catherine's other son owned a similar establishment on State Street. Both businesses sold ice cream, which naturally needed to be "ice" cold. By 1903, when the Hangsterfer family ceased ownership, another confectionery owner, Thomas Brogan, began his own ice company. (Courtesy of the Bentley Historical Library.)

Cold Fun
The river in winter was not all work. There were ice-fishing and ice-skating parties, such as this one hosted by Frank Maynard. (Courtesy of the Bentley Historical Library.)

That Dam Man
Gardner S. Williams, though born in Saginaw, Michigan, in 1866 and relatively unknown to modern townies, had a profound influence on the city. Williams studied engineering at the University of Michigan, graduating in 1889. Between 1904 and 1911, he taught experimental hydraulics and was the engineer in charge of the hydraulic lab at Cornell University. Williams then returned to his alma mater as professor of civil, hydraulic, and sanitary engineering. He codeveloped the Hazen-Williams hydraulic tables, which are used to mathematically determine the strength of water pipes by calculating the relationship of flow, friction, and pipe material. His national reputation resulted in his being sought as an expert witness in hydraulic-failure suits throughout the United States. Williams designed the Barton Dam (pictured) in 1912, Argo in 1913, and Geddes in 1916; he also served as consultant to Detroit Edison. Williams retired in 1924 and died in 1931. (Courtesy of the Bentley Historical Library.)

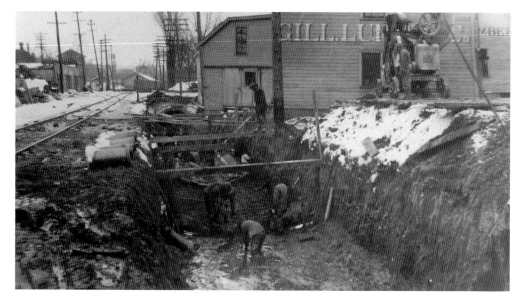

Pipe Dreams

John Allen's eponymous creek never was a good source of water for powering mills. It simply did not have sufficient flow. Tanneries did use it for soaking hides and pelts, and a foundry used it for sand casting. Two breweries used the creek's waters for cooling beer, but only the flour mill actually utilized it for power. When the Old West Side was a more rural setting, residents watered their cattle and horses in the creek. But sometimes, usually in the spring, there was too much water; hence, the flood plain west of First Street. The design of the newest incarnation of the Ann Arbor Y reflects this concern. The street-level floor is parking rather than interior space. The flooding was of sufficient concern that 87 homeowners petitioned the city through their 1st Ward alderman, Herbert Slauson, to install a storm sewer. In 1926, the city complied and contained Allen Creek within enormous pipes, pictured above. Despite being born in New York and raised in Iowa, Slauson attended the University of Michigan and graduated in 1877. He began his career in education in Iowa. After serving as superintendent of schools for several districts, he returned to Ann Arbor in 1898 to assume that role for the city's public schools; pictured below, he is sitting on the right with some students. For all his educational and civic efforts, in 1937, the new middle school was named for him. (Both, courtesy of the Bentley Historical Library.)

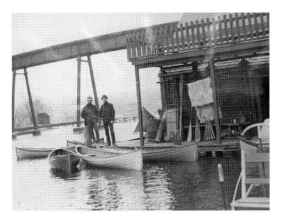

River of Doubt

When Dwight D. Eisenhower was 20, he stopped in Ann Arbor to visit his brother Edgar, who was a student at the University of Michigan. The year was 1911. The future general and president of the United States was on his way to begin his studies at West Point. While Edgar was in class, Dwight walked around town. He soon found his way to the Huron River, which is just a half mile north of main campus. He rented a canoe and spent a restorative afternoon on the river. Resuming his train trip East, Eisenhower seriously considered that he had made a mistake in choosing West Point. Perhaps he should turn around and attend the University of Michigan. But he decided to stay the course since West Point was free and Edgar was struggling to pay his tuition. 20th-century history would be quite different had Eisenhower changed his mind. (Courtesy of the Bentley Historical Library.)

The River Runs Through It

The University of Michigan's 1817 charter never stated it, but founders assumed that botanical gardens would be included. In 1907, the university created a botanical gardens and arboretum just a few blocks from its central campus. By 1899, landscape architect Ossian Cole Simonds was hired to evaluate other possible sites for the joint project between the university and the city. While the botanical gardens and arboretum are separate facilities, both are managed by the university. The arboretum continues under the name of Nichols Arboretum to honor a land gift from the Walter and Esther Nichols family. Other donations of land increased this town-and-gown effort to 123 acres available to Ann Arbor residents. Any time of the year is the right time to find people traipsing the trails through valleys, dales, and glens to enjoy an abundance of native and exotic trees and shrubs. And in the late spring, 800 blooming peony plants of 270 varieties burst into bloom. Residents flock to the "arb" to hear musical presentations in the amphitheater or to experience Shakespeare in a strolling presentation. (Courtesy of the Bentley Historical Library.)

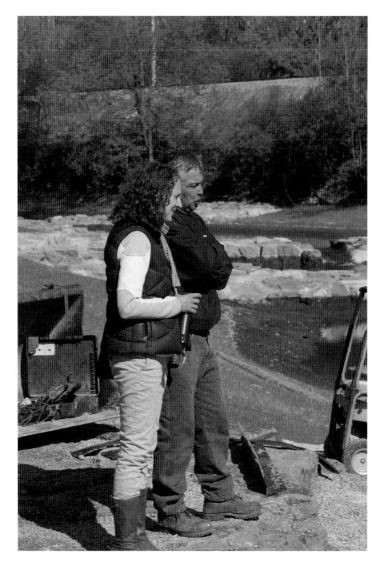

Boaters and Floaters

When Anson Brown built the millrace near Argo, there was a significant amount of water flowing through it. By the late 20th century, that millrace had become a mosquito-infested bog. Canoers and kayakers could either portage or, if water were high, attempt to paddle through it to rejoin the river below the dam. A little dirt walking trail meandered between the river and the millrace. Then, in 2005, state inspectors required the city to install toe drains or remove the dam. Cheryl Saam, recreation supervisor, had other ideas. She successfully oversaw the construction of the Argo Cascades. Why the cascades? She recalls telling a friend at a party about the project and the need for a name. Her friend immediately said "cascades," and that name also was preferred by the public. Gary Lacy, a recreational engineer, designed the cascades, which are a series of chevron shaped dams made of enormous blocks of Michigan limestone. The lowest portion of each rock chevron is open, allowing boaters and floaters to rush from one pool to the next until they make a final plunge into the river. Not only was the project less expensive than toe drains, according to Saam, traffic on the river has more than quadrupled since the cascades were built. She is pictured here with Todd Kaminski, TSP Environmental construction supervisor. (Courtesy of Cheryl Saam.)

CHAPTER TWO

The University of Michigan

The University of Michigan comprises a huge part of the unique mix that makes Ann Arbor. Founded in Detroit in 1817, the university did not arrive in Ann Arbor until after statehood in 1837. Its new home began with a 40-acre campus, created out of a wild meadow, and it had a faculty of four professors and seven students. One of the most interesting pieces of U-M history is that, even before the first building, named for Michigan governor Stevens T. Mason, was finished, the university purchased John James Audubon's *Double Elephant Folio* for $970 as well as a collection of geological specimens for $4,000. Considering the fact that tuition was only $10, such purchases seem extravagant but also very farsighted.

At first, students lived on campus. The curriculum was a classical one covering Latin, Greek, religion, rhetoric, mathematics, natural science, philosophy, literature, and so on. This is what East Coast schools taught. Daily chapel and Sunday religious service were required. It was Henry Philip Tappan who took this fledgling, perhaps even floundering, institution and put it on its path as a great research institution. After the Civil War, Michigan accepted its first African American students. Then, in 1870, after years of procrastination and debate, U-M allowed women to matriculate, and the "dangerous experiment" began.

The University of Michigan's influence on the community is reflected by the fact that, without any conscious effort, the majority of the people featured in this book (as well as both authors) have ties to the University of Michigan either as alumni/alumnae or as faculty/staff. If you ask a resident why he or she lives in Ann Arbor, more often than not the answer will be that they came to the University of Michigan and never went home.

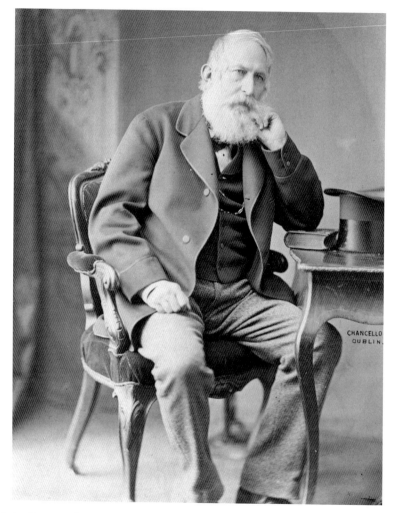

CHANCELLO
DUBLIN.

Tapping into Research

The University of Michigan has had many presidents. Of those, Henry Philip Tappan was one of the most significant. Born in New York in 1805, Tappan earned his bachelor's of arts and a theological degree by age 22. Before coming to Ann Arbor in 1852, he was a Dutch Reform pastor and a professor of philosophy at the University of the City of New York. When he arrived in Ann Arbor, the university was in disarray. Tappan, enamored with German universities, boldly stated that in all of the United States there were no universities. Then, he set to work making the University of Michigan one which provided a climate and facilities for research. One of the first things Tappan did was to shut down the student dormitory rooms. They were needed for other uses. From then on, all students had to find room and board elsewhere, thus shifting the burden of housing to the community. It was President Tappan who hired the university's first librarian and began the fine arts collection. It was also in Tappan's time that the observatory was built in 1854, the School of Engineering was established in 1855, and the School of Law was founded in 1859. He used his influence to stimulate graduate programs. As a result, the number of graduate students in 1861, despite the Civil War, rose from 154 a decade earlier to 533. Tappan would have been gratified to know that by 1871 that number had more than doubled. Due to friction with the Board of Regents, in 1863 Tappan resigned and went to Europe. He never saw the results of his efforts. Hopefully, he had heard how much the university had grown both in size and reputation before his death in 1881. (Courtesy of the Bentley Historical Library.)

Body Work

Moses Gunn, like so many early Ann Arborites, came from New York. He received his training as a surgeon at Geneva Medical College. As soon as he heard in 1850 that the University of Michigan was opening a medical school, he decided to move to Ann Arbor. Rumors abound that he brought with him from New York several cadavers for the anatomy lab, but the university did not offer a course in dissection until 1852. Studying corpses was very controversial at that time. First Gunn lived on Ann Street just east of State Street, but he eventually commuted from Detroit where he said there were more patients. Gunn served in the Civil War before moving to Chicago to teach at Rush University. He died in 1887. (Courtesy of the Bentley Historical Library.)

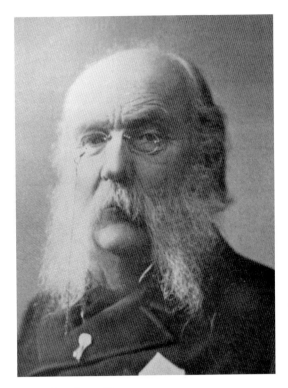

A Tree-Mendous Guy

Andrew D. White was 24 years old and newly married when he arrived in Ann Arbor in October 1857 to teach history and English literature at the University of Michigan. Having been a student at Yale University for both his bachelor's and master's, he was disappointed with the wild appearance of Michigan's campus. The University of Michigan's Ann Arbor campus was relatively new at that time. White described it as "unkempt and wretched," and so he began planting trees. After two years, he was named superintendent of grounds with a stipend of $75 per year. It was White's influence that inspired the class of 1858 to donate the oak tree just west of the Hatcher Library. It is considered the oldest tree on the campus and has been named the Tappan Oak for Henry Tappan, who was president of the university at the time. And it was Professor White who established what is perhaps U-M's most iconic feature—the Diag. White returned to New York when his father died in 1864. He was elected to the New York State Senate. There, he met Ezra Cornell. Together, they founded Cornell University, where White served as president until 1885. (Courtesy of the Bentley Historical Library.)

A Gentle Force

Another University of Michigan president, who was far less controversial than Tappan, was also named Henry: Henry Simmons Frieze. He was a professor of Latin (1854–1889) who became interim president between Haven and Angell. Interim or not, his decision to admit women to the University in 1870 permanently changed both the university and the country as women graduated and became professionals in a wide variety of fields. Also, it was under his leadership that University Hall was built where Angell Hall now stands. Finally, while he was president, the university expanded its library collection by almost 40 percent. Frieze influenced many aspects of Ann Arbor that remain to this day. He initiated a high school accreditation in Michigan to raise academic standards so students would be prepared for university work. Ann Arbor High School was the first to be accredited. He served on the Ann Arbor Board of Education. He was instrumental in the establishment of both the Messiah Club and the University Musical Society. And it was Professor Frieze who organized a concert to raise money to send Pauline Widenmann (later Mrs. Reuben Kempf) to the Cincinnati Conservatory of Music. Though the Frieze Building has been razed in order to build North Quad, Professor Frieze's contributions have been memorialized by naming the organ at Hill Auditorium after him. It was appropriate to do so because, as a student, Frieze earned money for his tuition at Brown University by playing the organ. (Courtesy of the Bentley Historical Library.)

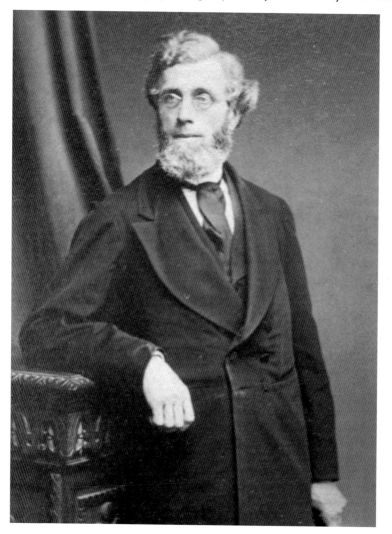

Mystery Woman

The first woman to teach at the University of Michigan was Louise Reed, born in Grand Blanc, Michigan, in 1850. She received both her bachelor's and master's from the University of Michigan in the field of microscopic botany and began teaching there in 1877. Having been in the first wave of female students at U-M, she was sensitive to the problems female students experienced. So she gained permission to have one room in University Hall designated as a lounge for women, which she furnished with items from her own home. She married Prof. Charles Stowell. In 1889, the couple left Ann Arbor for Washington, DC, where Louise worked for the Department of Agriculture. She was the first woman on the school board of Washington, DC, a trustee of the Girls Reform School of the District of Columbia, and chair of the sanitation committee. Louise authored a textbook and more than 100 articles. She also edited her field's professional journal for seven years. Her fame spread to England, where she was the first woman elected to the Royal Society; however, she is virtually unknown in Ann Arbor. (Courtesy of the Bentley Historical Library.)

Avowed Workaholic

When President Angell asked Eliza Mosher in 1895 to come to the University of Michigan as its first dean of women, she turned him down flat because the School of Medicine would not accept her in its faculty even though she had graduated from that school. After much wrangling, Mosher did come to Michigan but taught in what is now the College of Literature, Science, and Arts. It took 25 more years before a woman, Elizabeth Crosby, became a professor in the School of Medicine—and she did not have a medical degree. Born in Petersburg, Michigan, in 1888, Crosby received a bachelor's of science in math from Adrian College, a master's of science in biology, and her doctorate in anatomy from the University of Chicago. Then, she returned home to care for her elderly parents. In Petersburg, Crosby was a teacher, then the principal, and lastly, superintendent of schools, all within five years. In 1920, she transferred to teacher in U-M School of Medicine where she spent the rest of her career. Dr. Crosby was the first woman to receive the University of Michigan Faculty Achievement Award. She also won the National Medal of Science in 1979. An avowed workaholic, Crosby died at age 95. (Courtesy of the Bentley Historical Library.)

"Pond Forever"

Ann Arbor native Irving Kane Pond made his mark in the Midwest as an architect, athlete, and author. He used his University of Michigan engineering degree to design prominent buildings in Chicago and student unions and libraries on the campuses of Purdue, Michigan State, Kansas University, and the University of Michigan. He also was a published author of fiction, poetry, and essays. But while still an undergraduate student, he was a member of U-M's first Wolverine football team. When Michigan played its inaugural intercollegiate game against Racine College at Chicago's White Stocking Park in 1879, Pond scored the first touchdown in U-M history. The crowd responded with cheers of "Pond Forever." "To avoid being tackled," Pond recalled, "I was forced to mount the bleachers and run eastward along them until I was opposite the goal when I stopped suddenly and, fearing a touchdown in the bleachers would not count, jumped over the heads of my pursuers to the ground." Michigan won 1-0. An amateur acrobat and physical fitness buff, Pond was photographed on his 80th birthday, in June 1937, performing a back flip. (Courtesy of the Bentley Historical Library.)

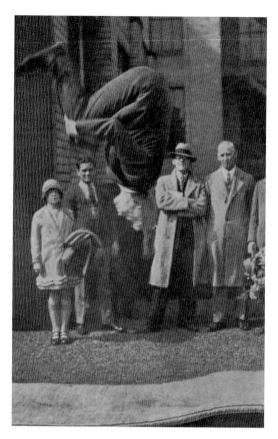

Here Comes the Judge

Like so many early Michigan settlers, Thomas McIntyre Cooley was born in New York in 1824, the same year Ann Arbor was founded. He began his study of the law in New York. His apprenticeship then took him to Adrian, Michigan. He passed the Michigan bar in 1846 and began his practice first in Tecumseh and then returned to Adrian. In 1857, Michigan established its supreme court, for which Cooley became the recorder. That same year, the Michigan Legislature asked Cooley to compile all general statutes into a single book. Those experiences resulted in his moving to Ann Arbor two years later to teach at the University of Michigan's School of Law. In 1864, Cooley was named a justice of the Michigan Supreme Court. He remained on the court for 21 years. In addition, he was a prolific writer of articles and books concerning the law. Cooley bequeathed his State Street home to the university to be used as a men's union. That structure was razed in 1916 in order to build the union that exists today. (Courtesy of the Bentley Historical Library.)

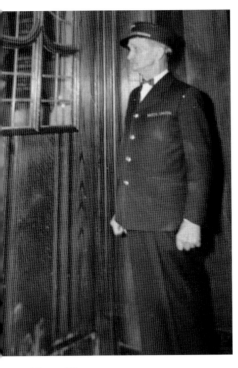

"Please Use the Side Door, Ma'am"

Women entering Michigan Union via the front entrance on State Street were greeted by that phrase. George Johnson, pictured, was there to remind female students and visitors that only men were welcome through the front door. It was a men-only gathering place since the union's establishment in 1904. And it remained men only with a woman only welcomed when escorted by a man. Eventually, the side entrance to which Johnson referred was known as the "ladies' entrance," giving women access to the lobbies, the dining rooms, and the ballroom on the second floor. There was a dining room on the north side of the building, known as the "ladies' dining room." It was not until 1968 that women were granted equal access to the entire building. There is a rumor that even the wife of Sen. John F. Kennedy was not permitted to enter the union through the front door but had to use the side door when her husband gave his Peace Corps speech on the front steps. George Johnson was not there when the Kennedys visited. He died in 1946, having manned his station at the front door for 26 years. (Courtesy of the Bentley Historical Library.)

True Blue

Pattengill School was named for Albert Henderson Pattengill, who was born in New York in 1842. After receiving his bachelor's of arts from U-M in 1868, he became principal of Ann Arbor High School. The next year, he returned to U-M for his master's of arts. From 1869 on, he taught Greek at his alma mater. While an undergrad, Pattengill was a star baseball player. Legend has it that he hit a ball from 100 feet south of North University Street, and it landed on the skylight of the old medical building on East University Street. A few professional ballplayers express doubt, but the legend stands. In the last game of the 1867 season, his team decimated the state champion, Detroit Baseball Club, 70-18. That same year, he was one of three on the committee that chose maize and blue as the university's colors. Pattengill's interest in sports never waned. He helped form and later chaired the Western Intercollegiate Conference, now called the Big Ten. He served on U-M's Board of Athletic Control from its inception in 1894 until his death in 1906. That board established rules for play and sportsmanship. Pattengill's interests extended beyond the university. When he realized that the United States was not planning to send athletes to the 1900 summer Olympics in Paris, he organized a fundraiser to send four of U-M's best athletes to the games. In fact, the 1904 Olympics in St. Louis, Missouri, has been dubbed the "Michigan Olympics" due to the number of medals won by University of Michigan athletes: six gold, two silver, and one bronze. (Courtesy of the Bentley Historical Library.)

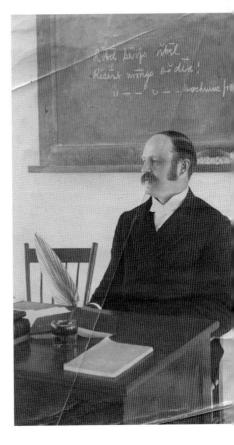

He Did It All

From law student and teacher to oil fieldworker and from baseball and football player to coach and athletic director, Fielding Yost did it all. In 1901, Yost was hired as head football coach for the Michigan Wolverines football team, a position he held through 1923 and again in 1925 and 1926. During this time his teams won four straight national championships and beat Stanford in the inaugural Rose Bowl. Yost invented the position of linebacker, the field house concept, and oversaw the first building on the U-M campus dedicated to intramural sports. He brought coaching to a professional level and was paid as much as a professor. Though noted for his contributions to football and other collegiate sports, Yost was also a successful businessman, lawyer, and author. He is often noted as a pioneer in bringing college football into a national passion. (Courtesy of the Bentley Historical Library.)

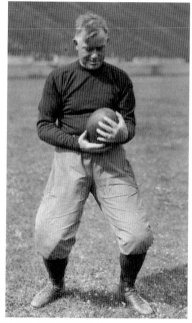

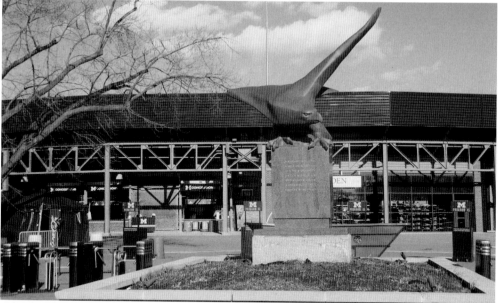

Wrong Species

Every day, thousands of Ann Arborites drive by the Michigan Stadium. On football Saturdays, more than 100,000 fans walk through the main entrance past an enormous 24-foot-tall bronze statue. One would expect it to be a wolverine, since Michigan is the Wolverine State and the wolverine is the university's mascot. But no; it is an eagle. Coach Fielding Yost gets the credit for the original idea; Marshall M. Fredericks gets the credit for the sculpture itself. It is not meant to be the football team's mascot. It is a memorial to all the men and women from the University of Michigan who have died for their country in time of war. Look closely, and one will see that the eagle's talons grip the pedestal as its body protects a wreath of honor beneath. (Photograph by Susan L. Nenadic.)

The Voice

It was not his prowess on the collegiate tracks that brought this would-be football player into the hearts of Ann Arborites and U-M fans. His fame was not because of his world record in the 440-yard dash nor his continuance of first or second place in relays and the 600-yard dash. It was not for his third leg of a two-mile relay in a meet that helped the University of Michigan squad break the college record and equal the world record with a time of 7:55:6. What made him an Ann Arbor legend was his 37 years as "the Voice of Michigan Football." While covering 362 straight games for the Maize and Blue, Bob Ufer developed a style of broadcasting opponents termed "partisan hysterics." He broke every rule of sports broadcasting and was heard to say, "Prejudiced? Partial? You better b'leeve I am. Michigan football is a religion, and Saturday's the holy day of obligation." People found him to be so entertaining that they turned the sound down on TV coverage and substituted Ufer's radio report for the audio. In November 1976, former president Gerald R. Ford, who had played football at Michigan, asked Ufer to be the keynote speaker at his kickoff rally for the presidency. Michigan's football team just happened to be ranked No. 1 in the country at the time, and Ufer capitalized on that, giving an electrifying speech that transformed a 20,000-member political forum into the largest college pep rally ever assembled. President Ford did not mind a bit. As Ufer would say, "MEE-CHIGAN can do anything." (Courtesy of the Bentley Historical Library.)

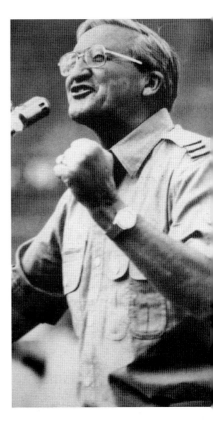

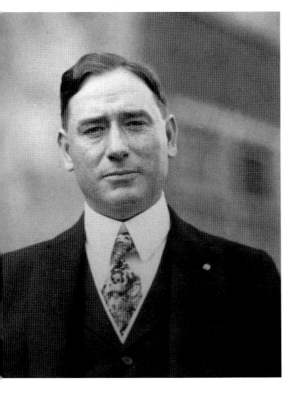

Burton the Builder

Marion Leroy Burton had many proud accomplishments during his three-year term at U-M. The fifth president of the University of Michigan, the youngest to hold that office, and the man who invited Robert Frost as poet-in-residence was a Congregational preacher who nominated Calvin Coolidge for president at the 1924 National Republican Convention. When Burton died in 1924, students hoped to raise the funds needed to make Burton's dream of building a clock tower on campus come true, but the challenge proved too great. The alumni association's fundraising plan was hampered by the Great Depression. The tower plans were filed away. It was not until 1935 that the alumni association was able to dust off the plans and begin building the tower. (Courtesy of the Bentley Historical Library.)

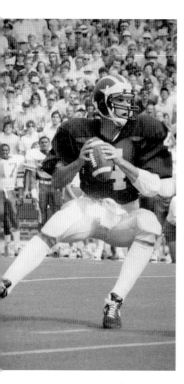

No. 4

The Harbaughs are a football family. Jack Harbaugh, the father, coached at U-M. For part of one season, John, then a senior at Pioneer High School, and his younger brother, Jim, both played on the varsity team. Though the family moved, and Jim graduated from high school in California, he returned to be the University of Michigan's starting quarterback (pictured), a Heisman finalist, and a victor at the 1987 Rose Bowl. As a result, the Chicago Bears drafted Jim in the first round. Jim Harbaugh began climbing the professional ladder in 1987, first as quarterback, then as quarterback coach, and finally as head coach for the San Francisco 49ers. Meanwhile brother John found his way into coaching directly after playing collegiate football. After graduating from Miami University, he became assistant coach at five different universities, including Western Michigan, before being hired in 1998 as the special teams' coordinator and defensive backs' coach for the Philadelphia Eagles. Ten years later, he became the head coach for the Baltimore Ravens. The Harbaugh brothers have set two National Football League (NFL) milestones. They are the only coaches in the history of the NFL to reach three conference championships in the first five years of their coaching careers. And they made NFL history by competing against each other in the 2013 Super Bowl. That day, the victory fell to John by a narrow margin of 34-31, but it did not stop the University of Michigan from hiring Jim as head football coach for the Wolverines in 2015. (Courtesy of the Bentley Historical Library.)

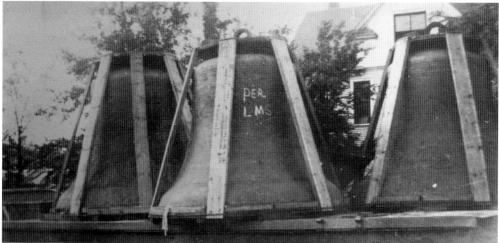

Baird's Bells

Charles Baird was the student manager of the U-M football team for five years. Three years after graduation in 1895, he became the first director of athletics. It was Baird who hired Fielding Yost as football coach. Baird resigned in 1909 to become a banker in Kansas City, but he never lost interest in the university. When he heard about the plans for a tower, he pledged $70,000 for a carillon weighing 43 tons. The Baird Carillon is one of the finest in the world. The tower hosts a carillon containing 53 bells. But it is the clock within the 212-foot reinforced-concrete-and-limestone tower with which Ann Arborites are most familiar. The clock can be seen from various areas of the city as the heaviest bell, at 12 tons, rings out the hours. Five other bells record the quarter hours, keeping students and residents on time. (Courtesy of the Bentley Historical Library.)

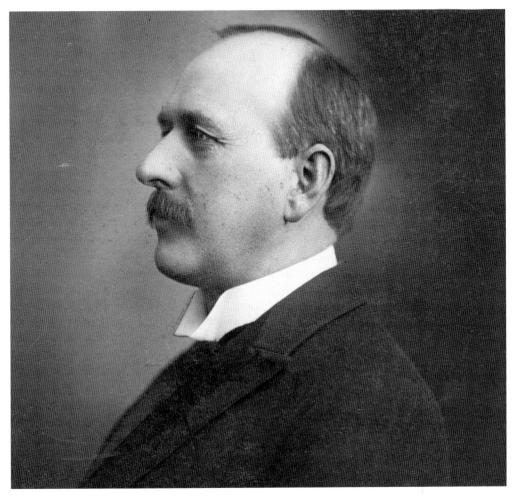

Lessons in Lovemaking

An allegation appeared in a 1903 *Chicago Tribune* article by University of Michigan freshman "Jam Handy" that Thomas Clarkson Trueblood, U-M professor of elocution and oratory, supposedly taught a course in "Lessons in Lovemaking." The *Tribune* headline "Learn Sly Cupid's Tricks; Students at Ann Arbor Take Lessons in Love Making" suggested Trueblood was instructing male students on romance rather than oratorical technique. Actually, he taught the delivery of extracts from oratory masterpieces. One extract involved a scene where a man kneels before a woman, pleading for her hand. The university suspended Handy for a year. Trueblood continued his U-M affiliation for a total of 67 years. Beginning in 1884, he taught speech, a course no other university offered. His course was so popular that he was given permission to form a speech department, the first of its kind in the world. But Trueblood made more headlines when he bucked the segregation policy and put African American student Eugene Joseph Marshall on his debate team. Marshall won a 1903 championship. The *Ann Arbor Argus* reported, "For the first time in the history of American universities, a colored man has won his highest honors in oratory in fair and free competition with all comers." Trueblood was a winner in his own right as the faculty tennis champion who gave up that game and took up golf, becoming Ann Arbor Golf Club's champion. In 1901, Trueblood organized and coached U-M's first golf team, defeating the University of Chicago in the first intercollegiate match held in "the West." Trueblood's teams won National Collegiate Athletic Association (NCAA) Championships and Big Ten Conference Championships. He also coached two NCAA individual champions before retiring at the age of 80. (Courtesy of the Bentley Historical Library.)

A Royal Joker

Known as "Queen of the Organ World," this royal is a compulsive joke teller who collects jokes in a "little black book" with reminders of assorted punch lines. Concert organist Marilyn Mason was also a recording artist and a teacher and professor emerita at the University of Michigan, having joined the U-M faculty in 1946. Born in Oklahoma in 1925, her career has taken her throughout the world with performances in Europe, Latin America, and Egypt. And she was the first American female organist to perform in Westminster Abbey. Mason has served as adjudicator at almost every major organ competition in the world. She has commissioned and premiered 75 works for organ and is recording the complete organ works of Pachelbel for the Musical Heritage Society. For a performance of all Bach's organ compositions, she ordered the works to be photographed and put on slides so the audience could see the musical notes while she played. For well over 50 years, she has led student tours of Europe where they could hear and play the great organs of the world. At a reception after one of her concerts, a woman commented about how lucky Mason was with her career. Mason smiled and thanked her and then turned to her host and said, "Funny, the harder I work, the luckier I get!" (Courtesy of the Bentley Historical Library.)

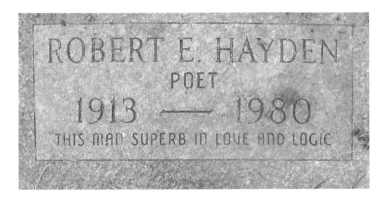

ROBERT E. HAYDEN
POET
1913 — 1980
THIS MAN SUPERB IN LOVE AND LOGIC

Poet Laureate

Asa Bundy Sheffey was born in Detroit in 1913. A foster family with the surname Hayden raised him, so Asa took their last name and changed his first name to Robert. Robert Hayden was small and near sighted, which caused him trouble in school, but he attended Detroit City College (now Wayne State University). In 1936, he left school to work for the Federal Writers' Project, where he researched African American history and folk culture. He came to the University of Michigan, where he won a coveted Hopwood Award and studied with W.H. Auden. He received his master's of arts in 1942, two years after his first collection of poetry was published. Hayden taught at Michigan for several years before joining the faculty at Fisk University in 1946. He returned to his alma mater in 1969 and died in Ann Arbor in 1980. He is buried in Fairview Cemetery with his wife, Erma. Robert Hayden was the first African American to serve as consultant in poetry (now called poet laureate) to the Library of Congress. He was the first African American professor at the University of Michigan. His most famous poem, "Those Winter Sundays," tells of a man remembering all the kindnesses shown him as a child— kindnesses for which he failed to be grateful. The poem ends, "What did I know, What did I know / of love's austere and lonely offices?" It speaks to all people, since everyone was once a child who probably took his parents' help for granted. (Photograph by Susan L. Nenadic.)

Monuments Man

Born in Minnesota, Ralph W. Hammett served in the Navy during World War I and then came to Ann Arbor to teach architecture at the University of Michigan. He designed many buildings, including the Lloyd Douglas Chapel and St. Andrew's Parish Hall. He also bought and refurbished Guy Beckley's house, which was on the edge of total collapse. What makes Ralph Hammett truly legendary is that, at age 48, he joined the Army in 1944. He then became one of the first three members of a team called the MFAA. MFAA stands for Monuments, Fine Arts, and Archives. Ralph Hammett was a monuments man! Stationed in Paris, he is credited with designing a catalogue system that facilitated returning art stolen by the Nazis back to its rightful owner. In the movie written by George Clooney, it is Matt Damon's character who works with Cate Blanchett's. In real life, it was Ralph Hammett. Perhaps his biggest coup was saving Chartres Cathedral after the retreating Nazi troops placed 22 bombs around its perimeter. (Courtesy of the Bentley Historical Library.)

Dear Aunt Ruth

Though she had no children of her own, her extended family numbered as many as 2,200 scattered across the globe. They wrote to her often. During World War II, she left her position as a receptionist at the University of Michigan each day for her second job as Aunt Ruth. Ruth Buchanan wrote to U-M students, faculty, staff, and alumni serving in World War II. She mailed 17,828 letters; 6,952 birthday cards; 7,398 get-well cards; and more than 57,000 copies of the student newspaper to those stationed in the United States, recuperating in hospitals, or seeing action in Europe and the Pacific. The numbers were staggering; their response enormous. The students were her family. She saw them as nieces and nephews and requested they call her Aunt Ruth. They obliged by the thousands. Servicemen and women invited her to their weddings, shared news of promotions, honors, and broken hearts. Several sent small souvenirs, like military patches, postcards, foreign currency, and photographs. Others mailed dollar bills to help with paper and postage costs. After Buchanan's efforts drew national attention, greeting card companies supplied her with stationery. Gen. Dwight D. Eisenhower and Adm. Chester Nimitz commended her support of US troops. And the Emblem of Honor Association, which typically recognized women with four or more sons in the military, awarded Buchanan its coveted Emblem of Honor pin. Buchanan regularly wore the pin over her heart. (Courtesy of the Bentley Historical Library.)

CHAPTER THREE

Town and Gown

The University of Michigan's 40-acre main campus is bounded on the south by South University Street. On the north is North University Street, and on the east, until it morphed into a pedestrian mall, was East University Street. The pattern is clear, yet on the west there is no West University Street, and there never has been. The street to the west of the main campus is State Street. That little inconsistency reveals a piece of Ann Arbor history. When Michigan was moving toward statehood, many in Ann Arbor wanted their town to be the state capital. They hoped that the 40 acres to the east of State Street would be the site of the state's capitol building. However, the capital became Lansing. Ann Arbor received a better designation; it became the home of the University of Michigan.

At first, there was nothing separating the town and the campus. It did not take long, however, before a fence was installed to keep grazing animals owned by residents from using the campus as their dining hall. Later, there was a proposed plan to enclose the entire 40 acres with walls like Oxford and Cambridge. Fortunately, that never happened. The campus remains open to everyone. The decision to keep campus open symbolizes the relationship between the town and university.

It is not just on football Saturdays that Ann Arbor is filled with people dressed in maize and blue. Residents attend campus events; utilize the Ingalls Mall for Summer Fest; volunteer at university venues, such as the art museum and Hill Auditorium; or simply just enjoy a stroll around campus. Likewise, university faculty organize town events, such as FestiFools, and students mingle with the community at the Y, churches, and restaurants.

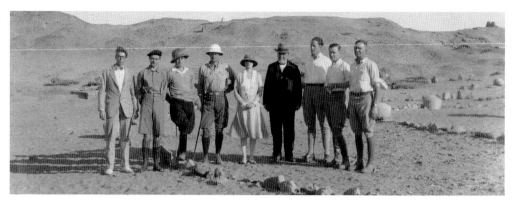

A Passion for Collecting

Professor of Latin, ardent archaeological collector, and humanitarian, Francis Kelsey brought fame to the University of Michigan and his name to the university's museum of archaeology. His passion for collecting antiquities took Kelsey (fourth from left) to excavations throughout the Mediterranean countries and the Near East. He also contributed to relief work after the Armenian genocide and strove to improve the lives of impoverished Belgian children after World War I. Kelsey's collecting of ancient artifacts originated as enhancement to his classes. He began in 1893 with a little more than 100 pieces. Then he bought 1,096 objects from dealers in Tunis, Rome, Capri, and Sicily. For 30 years, he collected pottery, figurines, painted stucco, tombstones, and coins. During the 1920s, he bought the ancient papyri that began U-M's collection, which is one of the top five in the world. Kelsey directed excavations at important Roman sites in Asia Minor and the Graeco-Roman site of Karanis, which yielded 45,000 finds that were shipped to Ann Arbor. Kelsey's collections are the mainstay of U-M's assemblage of daily-life objects from Graeco-Roman Egypt, the finest to be found outside of the Cairo Museum. (Courtesy of the Bentley Historical Library.)

Picture This

Eugene Power is the quintessential Michigan success story. Today, Google is using computer technology to digitize books; in 1938, micro-photography was the new technology, and Power quickly saw its potential. After receiving both his bachelor's of arts and master's in business administration from the University of Michigan, he established University Microfilms International. During World War II, while the Nazis were bombing England, he worked in British libraries microfilming books and documents in order to preserve them. Queen Elizabeth II knighted him for his efforts. University Microfilms International (UMI) was instrumental in the development of Xerox copiers. Xerography put out-of-print books back in readers' hands. In 1962, the Xerox Corporation bought UMI for $8 million. Power's business success resulted in his serving as a Regent for the University of Michigan and chairman of the Ann Arbor Summer Festival. He also was a member of the council for the National Endowment to the Humanities. In 1967, he established the Power Foundation. The Power family's generosity is remembered each time patrons go to the University of Michigan's Power Center for the Performing Arts. (Courtesy of the Bentley Historical Library.)

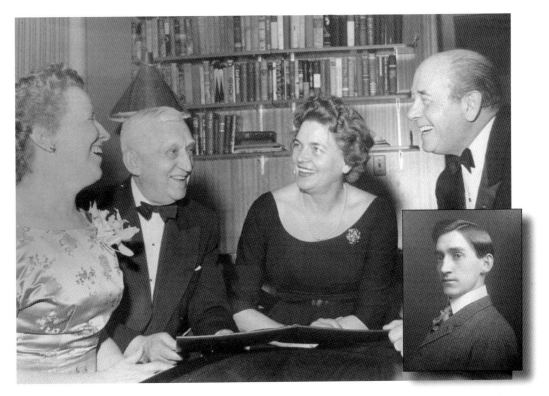

"Go Get 'im"

Charles A. Sink came to Ann Arbor as a student and never left. He earned his bachelor's of arts from the University of Michigan in 1904 and began a long association with the University Musical Society (UMS). While the society is located on the Ann Arbor campus, it is not part of the university itself. Sink served as the society's first secretary, then its executive manager, and finally as president, a position he held for 41 years. It was Sink who persuaded U-M to build Hill Auditorium, which has acoustics considered to be one of the best performance halls in the country. Then, Sink invited such luminary performers as Eugene Ormandy, famed conductor of the Philadelphia Orchestra. Sink not only arranged concerts, but he also made performers feel welcome by making sure they experienced generous hospitality while in Ann Arbor. Sink himself met all trains carrying performers. The photograph above is of the Sinks (left) enjoying their time with Mr. and Mrs. Ormandy (right). Situated in a relatively small Midwestern town did not deter Sink's ambition to bring the best to Ann Arbor. His direction to his UMS staff was "if there's a great artist out there, go get 'im and bring 'im to Ann Arbor. We've got the facilities, the audience and the will to make it happen." Though Sink passed away in 1972, UMS continued the tradition with performances by Martha Graham and her dance company, Yo-Yo Ma, Leonard Bernstein, Marion Anderson, and Luciano Pavarotti as well as Sweet Honey in the Rock and Ravi Shankar. (Both, courtesy of the Bentley Historical Library.)

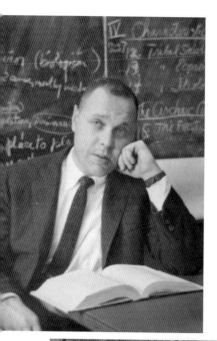

An All-Nighter

Ann Arbor had its sit-ins in the 1960s, but it also was the site of the very first teach-in. Many liberal faculty members at the University of Michigan opposed the escalating war in Vietnam. In 1965, they met at the home of Arnold S. Kaufman, to discuss the possibility of a one-day faculty strike. Kaufman, philosophical by nature, came to the United States in 1939 to escape the Nazis whom he later fought in World War II. After the war, he taught philosophy at Michigan from 1955 to 1969. But it was not Kaufman who conjured the idea of a teach-in. That distinction belongs to Marshall D. Sahlins (pictured left), who received his bachelor's of arts from U-M in February 1952 and his master's of arts just four months later. After finishing his doctorate at Harvard, he returned to U-M to teach anthropology; hence, he was sitting in Kaufman's living room considering the best way the faculty could protest the war. Sit-ins may draw attention to a problem, but they are essentially negative actions. A teach-in, Sahlins thought, would be a learning experience. So it was on March 24–25, 1965, that 3,500 people stayed up all night to hear faculty members discuss the war. The idea caught on like wildfire, and it began in Ann Arbor. (Courtesy of the Bentley Historical Library.)

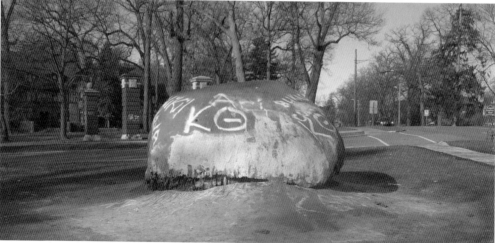

George Washington and the Glacier

While George Washington never visited Ann Arbor, a glacier did sweep through the area, leaving rubble and boulders. One of those limestone boulders was moved in 1932 from the city's gravel pit to a triangular bit of city land at the intersection of Washtenaw Avenue and Hill Street. Eli Gallup, a graduate of the University of Michigan's School of Forestry and Ann Arbor Park and Recreation superintendent, wanted to honor George Washington on the 200th anniversary of his birth in 1932. With an allocation from the city council of $15 and a contribution from the Daughters of the American Revolution (DAR), Gallup installed a base for "The Rock" with a time capsule buried under it. Painting "The Rock" began sometime toward the end of Gallup's 45-year tenure as superintendent. In spite of negative reactions, people continued to paint. At first, the parks department tried to clean "The Rock" after each new assault but soon gave up the losing effort. Not only do students from nearby Greek organizations paint, but schoolchildren and townsfolk have also been seen with brushes in hand. "The Rock" is painted so often that it feels perpetually damp. (Photograph by Susan L. Nenadic.)

And Then There Was Agnes

Agnes Inglis was born into a socially prominent, conservative family. Leaving U-M prior to graduating, she spent several years as a social worker in Detroit and Chicago. Returning to Ann Arbor, she became active in the anarchist, labor, and social movements. She held meetings at her house and spent her fortune on various causes. In the mid-1920s, with her funds depleted, she turned her attention to the Labadie Collection of radical history and international social protest at U-M. Inglis worked first as a volunteer and then as its first curator. Unpaid, she lived on an allowance from her brother and remained on the job until her death in 1952; she expanded the collection some twenty-fold by means of her own resources and contacts. Agnes was also a Sunday school teacher and a volunteer with the Ann Arbor YWCA. In 1911, she, with help from the YWCA, organized 12 women's groups to form the Social Purity Club. The club called for the suppression of "objectionable places and public characters," demanded enforcement of laws prohibiting sale of tobacco and alcohol to minors, and wanted the schools to include sex hygiene classes. (Courtesy of U-M Special Collections.)

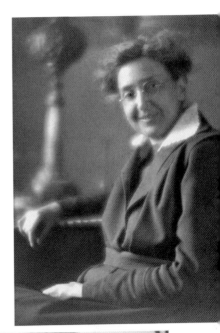

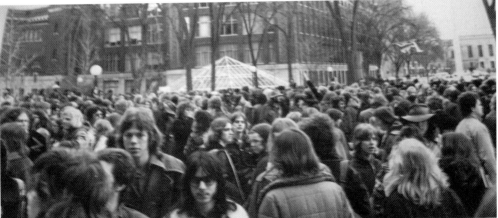

Wanna Light Up a Joint?

"You're from Ann Arbor? How about that Hash Bash?" That is the greeting Ann Arborites hear as they travel the world. The city's Hash Bash grew from campaigns in Michigan and across the country in 1969 objecting to the incarceration of local political activist and founding member of the White Panther Party, John Sinclair. In 1969, Sinclair was arrested and sentenced to 10 years in prison for possession of two marijuana joints. By 1971, the "Free John Now" campaign included the "John Sinclair Freedom Rally" on the University of Michigan campus. Celebrities in attendance included John Lennon, Yoko Ono, Abbi Hoffman, Stevie Wonder, and Bob Seger. A review of his case resulted in his release in December 1971. A few months after Sinclair's release, U-M students and city residents held an event to celebrate the reversal of the case. There were speeches and demonstrations in favor of marijuana legalization, music, and vendors. Because of Ann Arbor's lax marijuana laws, the event continued. Each first Saturday in April at "high noon," locals and visitors descended on the "Diag." Through the years, Hash Bash attendance has wavered from 3,000 participants in 1973 to none in 1985. But in celebration of Michigan's medical marijuana victory, by 2015 the number of participants had increased to between 8,000 and 15,000. (Courtesy of the Bentley Historical Library.)

Impresario

One of the things that makes Ann Arbor such a wonderful place to live is the opportunity to see and hear dramatic and musical artists from around the globe. The University Musical Society (UMS) collaborates with the university and uses campus venues for performances but supports itself through grants, contributions, and ticket sales. It has been around for 135 years, but its current chief executive officer Ken Fisher has broadened its programming both in quantity and in diversity. Ken Fisher was born and raised in Plymouth, Michigan. Fisher graduated from the College of Wooster in Ohio. He worked for 17 years in Washington, DC, in a variety of roles that prepared him for his current position at UMS. At each performance, he can be seen greeting concertgoers. Fisher went to Washington, DC, September 10, 2015, to accept the National Medal of Arts. This is the highest award the US government gives for the arts, and the first time it has been awarded to a university-related arts presenter. (Courtesy of the University Musical Society.)

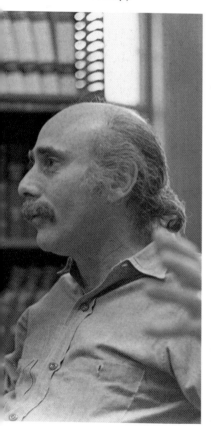

Resident Radical

On a beautiful fall day in September of 1954, a freshman was going to his English class. As he approached the steps to the building, he noticed a group of students with banners protesting the University of Michigan's decision to discipline professors who had refused to testify at the House Un-American Activities Committee. Alan Haber never made it to his English class. By December, he had established the Political Issues Club, which brought speakers like Eleanor Roosevelt to Ann Arbor. The Political Issues Club morphed into the SDS: Students for a Democratic Society. At its meeting in 1960, Haber was elected national president. As a result of all his extracurricular activities, it took Haber 11 years to graduate from the University of Michigan. They say the apple doesn't fall far from the tree, and that adage is particularly appropriate for Haber. His father, a professor and dean of the economics department at U-M, helped draft the Social Security Act. Thus Alan grew up in a liberal, New Deal home at a time when Ann Arbor was far more conservative than it is today. To pay the rent, Haber became a woodworker, but even his day job reflects his absolute commitment to social issues. Among all the creations he has made, his favorite is his "peace table." Its square bottom symbolizes conflict, while its round top represents peace. This table traveled to the Hague in 1999 for the 100th anniversary of the Hague Appeal for Peace. Sixty-two years have passed since that pivotal day in 1954. Alan Haber is still working toward his vision of what the world could be. He and his peace table both reside in Ann Arbor to this day. (Courtesy of the Peter Yates Collection, Bentley Historical Library.)

Fools Rush In

Mark Tucker has been an artist in Germany, Italy, and Boston. He has designed, constructed, and painted sets for movies, television commercials, and theater as well as being the art director for the Michigan Thanksgiving Parade. Now, he is art director and head puppeteer for U-M's Lloyd Hall Scholars Program for non-art majors. In his spare time, he throws parades. To engage his students through puppet production, he decided to replicate Italy's Carnevale de Viareggio. The idea developed into the FestiFools Parade held annually on the Sunday closest to April Fool's Day. This event features whimsical and bizarre human-

powered creations that float 15 to 20 feet above the Ann Arbor crowds. The community loved the parade and demanded more, so FoolMoon was born and has its own nighttime processional of illuminated sculptures on the evening before the parade. Now, as creative director for the nonprofit WonderFool Productions, Tucker's efforts engage communities in what he calls "Dynamic, educational, collaborative and entertaining public art experiences." (Courtesy of Myra Klarman.)

Red Tag Day

Every December since 1927, University of Michigan medical students have stood on downtown street corners asking passersby to donate money for children at the C.S. Mott Children's Hospital. In return, contributors are given little red tags to hang on their coats so that everyone knows they have donated. On the first "tag day," the Galen Society received $1,000, which funded a Christmas party for hospitalized children. By the 21st century, $65,000 was finding its way into the 501(C)3. A huge share of the proceeds funds the Galen's Workshop where hospitalized children can play and build and learn. This noble tradition was the brain child of William W. Thomas, class of 1928, and Dorothy Ketcham, head of the hospital's social service program. Before then, the Galen Society was more of a social honorary for medical faculty and students. They held annual "smokers" at the Michigan Union. The Galen Society remained an all-male club for almost 60 years. Finally, in 1970, exactly 100 years after women were allowed to matriculate at Michigan, females were allowed to join. (Courtesy of the Bentley Historical Library.)

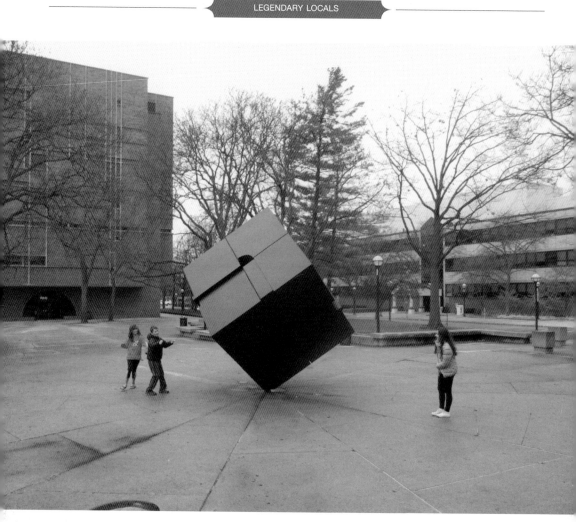

Give It a Spin

There is no shortage of public art in Ann Arbor. One of the most popular pieces is the enormous black cube in Regent's Park adjacent to the Michigan Union. Originally named the "Endover," Ann Arborites simply call it "The Cube." It beckons children and adults to come closer and give it a spin. The Cube is the brainchild of Tony Rosenthal, U-M class of 1965. He was born in Highland Park, Michigan, in 1914. As a boy, his mother urged him to take Saturday art lessons. That advice set him on his life's journey. He studied art at Cranbrook Academy in Bloomfield Hills, Michigan. Rosenthal's mentor at Cranbrook was Carl Milles. It was Milles who created "Sunday Morning in Deep Waters," which is the fountain between Hill Auditorium and the Michigan League. Despite that connection, these two sculptures could not be more different. Rosenthal's art was influenced by Picasso, while Milles's oeuvre reflects his admiration for the work of Rodin. There is, however, a serendipitous similarity between those two artists. Both men changed their names. Tony's birth name was Bernard, and Carl changed his birth name, Andersson, to Milles, which was his mother's maiden name. (Photograph by Susan L. Nenadic.)

Multifaceted Diamond

Phil Diamond turned 81 in 1981. His life revolved around three things, music, German, and track. Like so many, he came to the University of Michigan and never left. Originally studying music, he quickly changed his major to German but preserved his interest in music by forming a band called Phil Diamond and his Six of Diamonds. By 1928, his focus was on finishing his doctorate and courting Yendys, the woman of his dreams who later became his wife. Few people in Ann Arbor are aware of his scholarly book about German literature, but anyone who was in Ann Arbor in the second half of the 20th century would be familiar with the Liberty Music Shop established by Diamond and his friend Morris Luskin. They bought 60 record albums. The first day, they sold 44 of the 60 at 12¢ each. Meanwhile, Diamond had become increasingly interested in the sport of track. He amazed people by predicting winners. By 1935, Diamond was head timer for the University of Michigan track meets, and he was the first non-coach to join the US Track Coaches Association. Diamond did not just join; he became an officer, edited their magazine, and wrote their constitution. He was also the first non-coach to be admitted to the Track and Field Hall of Fame. (Courtesy of the Bentley Historical Library.)

The Nation's Official Pack Rat

Director of the University of Michigan's Bentley Historical Library Robert M. Warner gave Ann Arbor the Gerald R. Ford Presidential Library. Warner chaired the planning committee for the library. At Ford's request, he fought so that the library and museum could be located in two cities, in Ann Arbor at his alma mater, the University of Michigan, and in Grand Rapids, Ford's birthplace. The day after Ford left office, nine trucks moved some 15 million papers to a storage facility in Ann Arbor. Once the privately funded library was completed on the university's north campus in 1979, the millions of documents were moved in, and it opened to the public. Pres. Jimmy Carter appointed Warner to serve as the sixth archivist of the United States. In this position, he was in charge of the nation's historical documents, ranging from the Declaration of Independence to the Nixon tapes. (Courtesy of the Bentley Historical Library.)

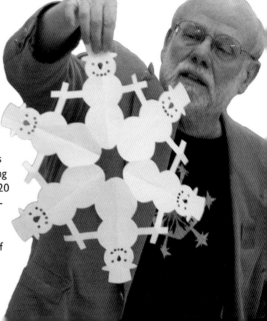

"Dr. Snowflake"

Dr. Thomas Clark worked at the University of Michigan Hospital and had a strong interest in art, which gradually invaded his professional life. Now known as "Dr. Snowflake," Clark frosted Ann Arbor and area art museums with his intricate paper snowflakes. Patients and a hospital secretary caught the fever and began making their own creations. Since his retirement more than 20 years ago, Clark's imaginative talent has resulted in one-foot snowflakes that have depicted biblical stories, the characters of Hans Christian Andersen, and nature. Clark offers an annual workshop sponsored by Gifts of Art. (Courtesy of Gifts of Art and Kathi Talley.)

CHAPTER FOUR

Ann Arbor "Firsts"

Everything has a first. It could be the first time a product appears on the market, such as in 1866 when Vernors Ginger Soda became available in Detroit. Vernors was the first soda pop sold in the United States. Objects often gain recognition as "firsts." The first mile of concrete roadway in the entire country was Detroit's Woodward Avenue in 1909. Detroit residents also were, in 1879, the first in the United States to receive phone numbers, and Detroit was the first city to erect a four-way, electric traffic light in 1918. A first might be when a new law is passed. Michigan was the first state to guarantee every resident a tax-paid high school education. It was also the first state to ban the death penalty. And Michigan State University was the first land-grant college in the United States. Michigan has many firsts to its credit.

But determining a historical first can be tricky. For example, was Madelon Stockwell the first woman to attend the University of Michigan? Yes—and no. In 1870, she was the first female student officially enrolled, but Alice Boise audited classes four years earlier. Was Eliza Mosher the first woman to teach at the University? Yes—and no. She was the first woman to become a full professor, but Louise Stowell was the first to teach as an instructor. The University of Michigan can claim many "firsts," some of whom were covered in Chapter 2. In addition to Louise Stowell, there were Robert Hayden, Elizabeth Crosby, and Elzada Clover. But it is not that difficult to find people, places, and events outside of the university to share the honor of being genuine Ann Arbor "firsts."

Tailor Made

One day in 1824, a man entered the tailor shop of Lorrin Mills in Buffalo, New York. He asked if his coat could be mended while he waited. Mills said that was fine and set to work. While the tailor worked, the customer regaled him with stories of how beautiful Michigan was. He specifically spoke of a new place called Ann Arbor because this customer was none other than John Allen, one of the founders of Ann Arbor. Mills was impressed, so he and one of his six brothers came to Washtenaw County to see if Allen's perception was accurate. They liked it so much that, in 1826, they and their entire extended family moved there. Lorrin Mills established the first tailor shop west of Detroit. He built the first brick house on the southwest corner of Main and Huron Streets. He married Harriet Parsons, one of the first schoolteachers in the area, who also taught in the first Sunday school west of Detroit. And in 1827, the Mills brothers formed Ann Arbor's first band, for which Lorrin was the bandleader.

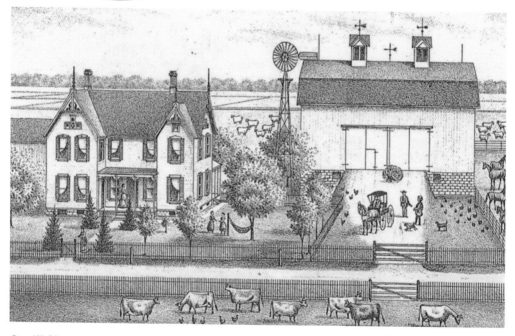

Aprill Shoe-ers

Both Jacob and Magdalena Aprill were born in Germany. They met in New York, where Jacob was an apprentice shoemaker and she worked as a domestic. They agreed that, when each had saved $100, they would marry and move west. Considering how little each one earned, it is incredible that, by the early 1830s, they were able to join the first wave of German immigrants to come to Ann Arbor. They opened the first shoemaking shop in Washtenaw County. Like so many couples in that business, he sewed the soles while she stitched the upper leather. Their frugal lifestyle and hard work allowed them to buy 340 acres of farmland in Scio Township. Their son William expanded the acreage. Both Jacob and Magdalena died at the farm in 1889, Magdalena surviving her husband by only nine weeks.

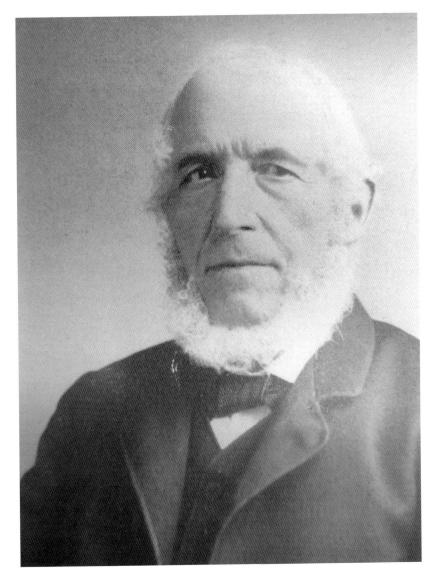

Ann Arbor's First Pharmacist

Many immigrants came from the area that is now Germany. These original settlers and their descendants had a profound influence on the development of Ann Arbor. One of those families was the Eberbachs. Christian Eberbach was born in Stuttgart, Germany, in 1817. There, he studied chemistry at the Stuttgart Polytechnicum and apprenticed for three years with an apothecary. When he arrived in Ann Arbor in 1838, he established himself as the town's first trained pharmacist. He began working in William S. Maynard's store but soon opened a shop of his own. In 1843, Christian Eberbach married Margaret Laubengayer, who was from another German family. By 1847, Christian was able to move his shop around the corner from Huron Street to Main Street, where he and his partner Emanuel Mann had constructed a new building. In addition, he helped found a bank, served as a volunteer fireman, and partnered with August Hutzel to start Hutzel's Plumbing, which remains to this day. Christian Eberbach was a musician and a singer. He served as Ann Arbor's mayor in 1868, helped found the Republican Party, and was a member of the Electoral College that put Lincoln in the White House. Throughout his life, he advocated government regulations of pharmacies.

Geometric Riddle

Ann Arborites love their parks. They boat at Gallup Park, listen to music at West Park, and skateboard at Veterans Park. But Ann Arbor's first park is hardly visited at all. It sits rather forlornly at what is now the intersection of Packard and Division Streets. Such was not the case when William S. Maynard and Elijah Morgan set aside the land in 1836. At that time, the designated parcel, named Hanover Square Park, was a rectangle much larger than today's park. The southern portion was lopped off for the building of Perry School. Then, the town whittled a bit more off the remaining park in order to combine three blocks of Packard Road to what was then called the Ypsilanti Road. As a result, Hanover Square Park today is a triangle. In 1982, the park acquired a 15-foot metal sculpture that had been removed from a traffic island at State and Liberty because business owners objected. Sculptor Ronald Bauer envisioned books tumbling when he designed the sculpture. He certainly must have been aghast when someone painted "stop" and "go" on his "Tree of Knowledge." (Photograph by Susan L. Nenadic.)

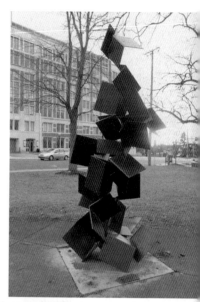

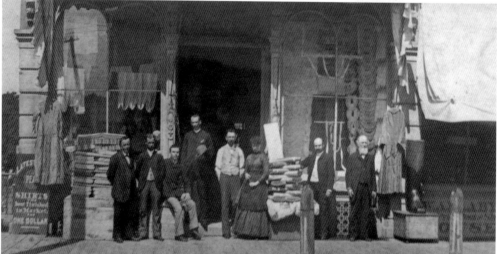

Bach to Bach

Bach School sits in the middle of the Old West Side, an area where many early residents were of German descent. Philip Bach's parents immigrated to Ann Arbor in 1829 when he was nine years old. He began his career clerking for Brown and Company and then for E. Root and Sons. Having gained business experience, he opened his own dry goods store with Peter H. Abel in 1867. The store is pictured here as it was in 1888; 67-year-old Philip Bach is on the far right. Bach was the first German-born mayor of Ann Arbor. He was elected in 1858. Bach also served for 34 years on the school board. He married Anna Botsford, daughter of pioneer Elnathan Botsford, in 1876. She, too, served on the school board. A group of women, led by Emma Bower, sued the city because they were paying local taxes and not allowed to vote. Their case went all the way to the Michigan Supreme Court, which decided in 1881 that women who paid local taxes could vote in local elections. As a result, in 1883, Sara Bishop became the first Ann Arbor woman elected to the school board. The following year Anna Bach also was elected. She later became the first female president. Thus, Anna served as president of the school board on which her husband also sat. (Courtesy of the Bentley Historical Library.)

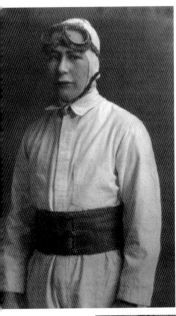

The Aranem Special

The Indianapolis 500 began in 1911. Since then, there have been 100 Memorial Day races. Most Americans recognize names such as A.J. Foyt and Al Unser, but they do not know the name Sam Ross, who remains the first Ann Arborite to drive—and almost win—that race. Sam Ross was born and raised in Ann Arbor. As a boy, he liked to tinker with motors and race cars. In 1922, he won 36 sprint races, and two years later, he was first in 17 of the 19 races he ran, which was no easy trick since the racetracks were dirt in those days. As a result, they were dangerous and dusty. And the winnings were small. But in 1928, Sam, age 27, prepared to race a car designed by Harry Miller; the car's name was "Aranem [short for Ross & Miller, R&M] Special." On that fateful Memorial Day, Sammy achieved and maintained the lead position in a pack of 35. The track at the Indianapolis Speedway was, at that time, paved with bricks. One would think that would make it safer but not so. Ross hit a bump that forced his head hard against the cockpit. He pulled into the pit, blacking out twice before his relief driver could take over. Wilbur Shaw jumped into the Aranem Special, gunned the engine, and the motor blew. End of race. (Courtesy of the Argus Camera Museum.)

State Street Surprise

Ellen Morse was a North State Street icon. In the beginning of her career, she and her mother, Hannorah Morse, a widow, owned a house together. But it was not long until Ellen owned seven houses some of which she had built. She rented these houses to University of Michigan students, teachers, doctors, and nurses. Morse, herself, lived in 307 North State Street, which is now painted purple. Neighbors would see her walking from one house to another with broom and mop as she did her own cleaning. Miss Morse's name is not known by many in Ann Arbor, but her houses are famous. The purple house, which she sold in 1915, became the home of the Inter-Cooperative Council for co-op housing. The house at 403 North State Street became the Anna Botsford Bach Home for impoverished elderly ladies, but it is the house at 419 North State Street that is the most significant for many Ann Arborites. Though she herself by age 87 was struggling financially, Morse gave the white house at 419 North State Street to the Sisters of Mercy, who used it as the very first St. Joseph Hospital. (Photograph by Susan L. Nenadic.)

A Scraggly Little Fair

In 1959, Bruce Henry (left) and Jim Davies (right), owners of Artisans, spearheaded a group of other South University Street merchants. They approached the Ann Arbor Art Association with the idea of expanding their annual bargain-day sales with an art fair. Despite some responses, the association gave it a try. That first fair had three small tents and string stretched between parking meters from which artists hung their work with clothespins. The association had to beg artists to participate. The next Ann Arbor Street Art Fair included carnival rides, animal acts, music, and even a fashion show. 30,000 visitors viewed the work of 261 artists. By the fair's ninth year, it expanded with the addition of two more fairs, and in doing so, the fair that started them all was renamed Ann Arbor Street Art Fair, the Original. Hosted together at the same time, the three fairs worked like a "well-oiled machine." The three 1969 fairs supported more than 400 artists, and 200,000 visitors contributing $300,000 to the local economy. In 2015, Ann Arbor Street Art Fair, the Original, celebrated its 56th anniversary; it still has bargain-day sales booths but now includes approximately 1,000 artists and a half million visitors. (Courtesy of the Peter Yates Collection, Bentley Historical Library.)

Plein-Air Dining

Except for deep winter, diners gather at curbsides to enjoy a variety of culinary offerings. Had it not been for Donald B. Reid, Ann Arborites may never have taken to this nearly three-season style of dining. In 1948, Reid bought a kit from the Dagwood Diner Company of Toledo to construct a less than 1,000-square-foot metal diner at the southwest corner of Liberty and Ashley Streets. The City of Ann Arbor gave him a variance to the building code with an amendment that appears to be custom written for the Dagwood. Supplies for Reid's 16-by-32-foot structure were trucked from Toledo, and the following year Reid opened the Dag-Wood Diner (the hyphen being a forced name change to avoid conflict with the famous sandwich of comic strip lore). Two months later, the 20-seat diner, enameled in bright yellow, offered outdoor seating, and Ann Arbor had its first sidewalk café. The restaurant continued as the Dag-Wood until 1971, when a new owner renamed it "The Fleetwood." Over the years, the building has had various owners and names; however, its return to Fleetwood Diner continues the legend. (Photograph by Susan L. Nenadic.)

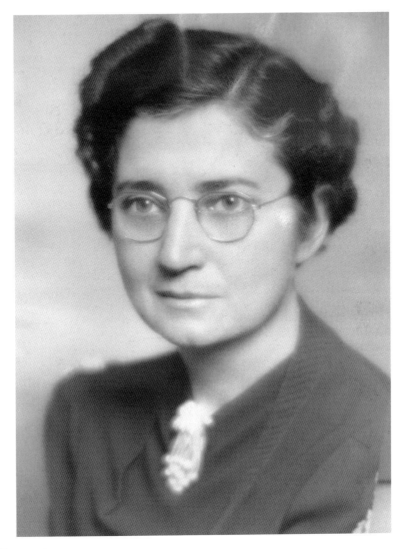

Lucky Clover

Sometimes a name really fits. Such is the case for Elzada Clover. Though a native of Nebraska, Clover's love of plants brought her to the University of Michigan, where she earned both a master's and a doctorate in botany. She then stayed to teach. In 1957, Clover became the curator of the University of Michigan's botanical gardens, where she developed the collection of succulents and cacti. Her faculty photograph, pictured here, does not do her justice. She looks like a prim and proper 1930s schoolteacher. She was anything but that. Elzada Clover was a gutsy and adventurous woman. In 1937, her interest in desert plants drew her to the Mexican Hat Lodge in southern Utah. There, she met Norm Neville. They began planning a trip down the Colorado River through the Grand Canyon for the next summer. Despite the treacherous rapids, she wanted to meet the challenge. No woman had ever done it. Norm designed three boats. They invited photographer Bill Gibson, Don Harris from the US Geological Survey, and two University of Michigan graduate students Lois Jotter and Eugene Atkinson to join them. Before Norm could advise this band of adventurers about how to handle the rapids, the boat with all the bedding and food broke loose. Don and Lois caught it but barreled down seven rapids before they could put to shore. 43 days and 666 miles later, Clover and Jotter became the first women to complete such a journey. Clover titled her memoir of that trip "Danger can be Fun." (Courtesy of the Bentley Historical Library.)

Brown's Town

Only old-time Ann Arborites still refer to the parking lot that fills the square between Ashley and First Streets and Huron and Washington Streets as the "Brown lot." It was named for Bill Brown, who came to Ann Arbor in 1914 to attend the University of Michigan. He served in World War I but returned to finish his degree. After graduation, he and Earl Cress established a partnership. They invested in just about everything, including real estate, bonds, loans, and a car dealership. Their partnership lasted 18 years. When they split, Brown took the insurance company and the car dealership, which occupied what is now "the Brown lot." It is appropriate that the parking lot should be named for Bill Brown because, as mayor of Ann Arbor from 1945 to 1957, parking was one of the key issues. Brown oversaw construction of the very first municipal parking lot at Washington and First Streets. It was not the first parking lot, but it was the first one operated by a city. (Courtesy of the Bentley Historical Library.)

World Hero

The first Jewish Holocaust memorial to be erected at a public university in the United States stands on the University of Michigan's campus in Ann Arbor. A sculpture by Leonard Baskin that portrays a huddled form with a hidden face dominates the plaza that was named for 1935 U-M architecture graduate Raoul Wallenberg. Wallenberg, during World War II, was a Swedish diplomat in Budapest. While there, he established a system of safe houses and placed Jewish residents under the diplomatic protection with official-looking visas of his neutral country. Through bluffing, bribing, and cajoling the Nazis, he risked arrest and death but managed to save tens of thousands of lives. After the Russians eliminated the German presence, Wallenberg continued his humanitarian work by arranging for food and supplies. Then, he disappeared. He was never heard of again. (Photograph by Susan L. Nenadic.)

Pioneering Planetarium

In response to Sputnik in 1957, American schools began a big push to increase math and science instruction. At that time, Ann Arbor's new high school, named Pioneer, was being designed. The school's principal, Nicholas Schreiber, wanted a planetarium added to the plans, and he had just the teacher to be director, John Rosemergy. Rosemergy taught physical science, physics, and astronomy. At that time, there were very few planetariums in the United States and none in high schools; however, Spitz Laboratories was manufacturing a small American projector for $5,000. Argus Camera of Ann Arbor donated $10,000 to the board of education for the equipment and installation costs. As it turned out, the Argus Planetarium was not just for students. In 1960, two Mercury 7 astronauts came to Pioneer High School to train since the planetarium they usually used was under repair. Rosemergy retired as director in 1986. By 2003, major renovations were needed. An Evans and Sutherland Digistar 3SP was installed. The canvas dome was replaced with aluminum, and the fixed seating was changed to movable chairs. Nine years later, IMRA Corp. sponsored a state-of-the-art D5 projector and LED lighting. IMRA's donation saved the planetarium from closure. In gratitude, the name was changed to Argus-IMRA Planetarium. (Both, courtesy of Pioneer High School.)

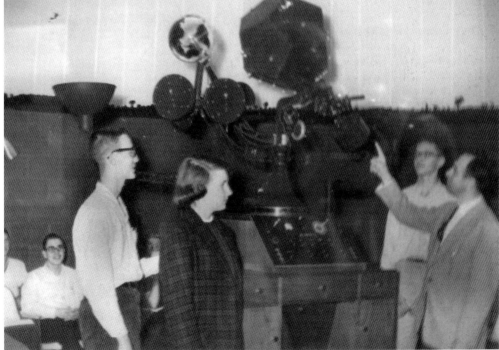

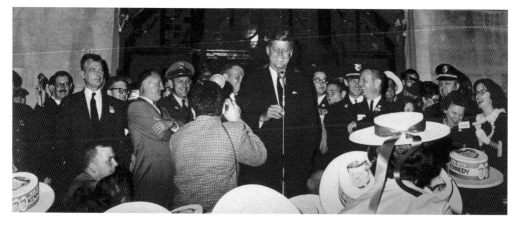

Much Is Given . . .

It was after midnight on October 14, 1960, when his plane landed at Willow Run Airport. By the time they had driven to Ann Arbor, it was 2:00 a.m. The candidate had been scheduled to arrive hours earlier. He probably was not expecting the crowd of thousands that had been waiting patiently that October night. Whatever fatigue the crowd was experiencing was immediately banished the minute John F. Kennedy arrived. He stood on the steps of the University of Michigan Student Union and challenged the students in the crowd to contribute to world peace through service in developing countries. His words were not planned. Possibly, he was responding to Nixon's claim the day before that 20th-century Democratic presidents had led the country to war. Within two weeks, Kennedy had his plan for the Peace Corps organized. More than 200,000 Americans—more than 2,000 from the University of Michigan—have responded to that call.

. . . Much Is Required

President Kennedy was supposed to give the May 22, 1964, commencement address at the University of Michigan. Because of his assassination, President Johnson agreed to speak. Johnson took the opportunity to voice a social program of his own. Kennedy's Peace Corps focused on foreign improvements; Johnson's plan centered around domestic injustices. He told the graduates that they had the opportunity—indeed they had the duty—to create a great society in which every citizen might share in its blessings of freedom and opportunity. For the rest of the Johnson presidency, Congress passed one new law after another to bring the great society to fruition; these laws included the Civil Rights Act of 1964, the Economic Opportunity Act of 1964, the Voting Rights Act in 1965, and the Civil Rights Act in 1968.

Not Ken Burns's Mother

Being in the right place at the right time is essential for success. And so it was in the 1960s when two people on Ann Arbor City Council, Lynn Eley and Eunice Burns, spearheaded the first fair housing law in Michigan and the eighth in the United States. Eley, elected in 1961, found a kindred spirit the following year when Eunice Burns was elected. They were not alone in believing that racial discrimination was wrong. There were more and more demonstrations against discrimination that slowly made the public aware of the problem. Eley, a professor of political science at the University of Michigan, assumed a political role that seemed a natural for him. Eunice Burns, however, had never been political. Her only experience in politics was going to ward meetings that her husband chaired. Before her election, her life had been filled with her duties as wife and mother to four children. But, "no," she likes to say, "I'm not Ken Burns's mother." Burns, a Minnesota native, grew up on a farm. With $800 from her aunt, she attended normal school, taught in Madison, Wisconsin, and was calling a square dance when she met her husband. Their union brought them to Ann Arbor for work at U-M's research fission lab. With the encouragement of her husband, Burns ran for city council, won, and began meeting with Eley every week to discuss issues. The duo actually voted against the first two drafts of the fair housing law, feeling there were too many loopholes or it just did not encompass enough. Finally, with the law's passage, it covered 95 percent of Ann Arbor housing. (Courtesy of Eunice Burns.)

Woman on the Move

The women of Michigan owe a huge debt to Jean Ledwith King. Born in 1928, King received her bachelor's of arts in English and her master's in history from the University of Michigan. Before her graduation from the law school in 1968, her energies were directed toward her husband and children. After graduation, however, she devoted her efforts toward equality for women. Something as simple as a woman's right to use her own name after marriage needed to be legalized. In 1970, King challenged her alma mater's admission, employment, athletics, and services policies. That resulted in the Department of Health, Education, and Welfare's first investigation of a university for gender discrimination. King was one of the founders of the Women's Caucus of the Michigan Democratic Party. This, too, was a first. King also challenged the Houghton Mifflin Publishing Company regarding gender discrimination in the textbooks they published. She won. For all her efforts on behalf of women, Jean King was inducted into the Michigan Women's Hall of Fame in 1989. (Courtesy of the Peter Yates Collection, Bentley Historical Library.)

Wheel of Progress

There are so many ways that Albert H. Wheeler and his wife, Emma, have affected Ann Arbor. They came to Ann Arbor from St. Louis, Missouri, so that Albert could finish his doctorate from the University of Michigan's School of Public Health. He then joined the faculty and became the first tenured African American professor at the University of Michigan. His specialty was microbiology and immunology. That was his day job. He and his wife spent the rest of their time as civil rights activists. Their vigorous response to discrimination in Ann Arbor was heightened when local banks refused to give them a mortgage on a house on Eighth Street even though they had a 30-percent down payment. The Wheelers were active in the NAACP and instrumental in founding the Ann Arbor Human Rights Council and the Michigan Civil Rights Committee. Albert Wheeler became the first African American mayor of Ann Arbor in 1978. In appreciation for all the work the Wheelers had done, the city named the park on Depot Street between Fourth and Fifth Avenues Wheeler Park. (Courtesy of the Bentley Historical Library.)

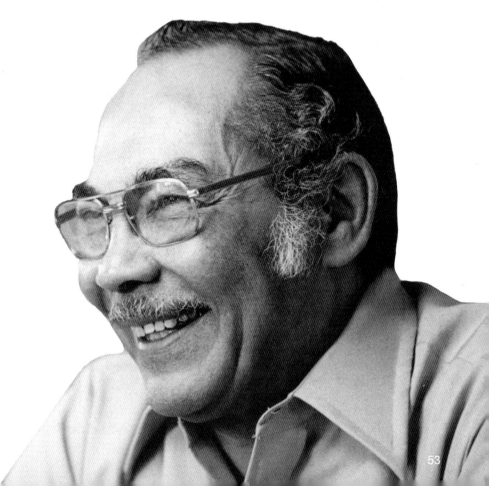

Ecology Advocate

Elizabeth "Liz" Brater is not an Ann Arbor native. She was born in Boston in 1951 and came to Ann Arbor in 1975 when her husband, Enoch, joined the faculty of the University of Michigan. At that time, Liz used her bachelor's of arts and master's of arts to teach and write. Her political career began in 1988 when she was elected to city council. Three years later, she became the first female mayor. Brater's mayoral legacy was her support for recycling. She advocated for both collection of recyclables and for a recycling facility. Brater (left) only served one term as mayor before being unseated by another woman, Ingrid Sheldon (right). Brater then served in the Michigan Legislature, where she continued to speak for the environment. In 1996, the Sierra Club named Brater "Legislator of the Year." In 2006, Liz Brater moved to the Michigan Senate but was barred by term limits from serving longer than 2010. (Courtesy of Ingrid Sheldon.)

CHAPTER FIVE

Fascinating Folks

Ann Arbor has, perhaps, more than its fair share of fascinating folks who have had or who are having interesting lives. Some of those people are local legends because places like the Nickels Arcade or Clague Middle School are named for them. Others have established something that the community values. A few townies have earned national reputations. Jack Lousma, the astronaut, is probably the most famous, but did you know that "Rosie the Riveter" was based on a local girl?

Saline, Michigan, may boast about the latest incarnation of Charlie the Dog, but in Ann Arbor Lewis the Cat brought smiles to big and little people's faces for years. And there are a few other towns that now have their own fairy doors, but it is known that the fairies came to Ann Arbor first. Some legendary townies, like Barb Lindeman and Coleman Jewett, have walked softly through their lives without fuss or fanfare, yet by their very existence have had a profound influence on others. No doubt, a few Ann Arborites might appear to outsiders as slightly odd or possibly even downright weird, yet the city's residents have embraced eccentric personalities, like Shakey Jake or Harvey Drouillard, as just part of the Ann Arbor scene.

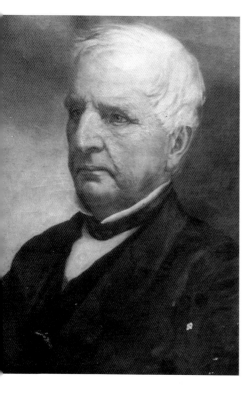

Pioneer Judge

There is a street in Ann Arbor that runs east and west from State Street to Main Street. A long time ago, the name of that street was North Street since it marked the northern boundary of the town. Today, however, it is called Kingsley in honor of James Kingsley. He was not only an early pioneer but a prominent citizen in Ann Arbor and Michigan. Kingsley was born in Connecticut in 1797. In 1826, he bought two plots just north of Ann Arbor. He cleared his land and studied law, opening his practice in 1827. In the following year, he became the judge of the probate court, a position he held until 1836. He married Lucy Ann Clark and built a home on the northeast corner of Detroit and North Streets. The list of his achievements and contributions is lengthy. He became a member of the Legislative Council of the Territory of Michigan in 1830, a trustee (later a regent) of the University of Michigan in 1831, a state representative in 1837, and a state senator in 1838. Kingsley also served twice as mayor of Ann Arbor. With all those accomplishments, it is not hard to see why the City of Ann Arbor named a street after him. (Courtesy of the Washtenaw County Historical Society.)

A Woman of Many Talents

Born and raised in Ann Arbor, Emma Bower studied homeopathic medicine at the University of Michigan. She graduated in 1883. For a few years, she practiced medicine. Then, her brother died, so she took over as owner and editor of the *Ann Arbor Democrat*. Her third and longest career was as head of the Ladies of the Maccabees, a women's club with 86,000 members, one third of which were in Michigan. The club's primary purpose was to provide life insurance for its members; however, she and her staff of 30 produced a club newspaper that had one of the largest circulations in the state. In addition to these business activities, Emma Bower was active at both the state and local levels. She served as president of the Women's Press Association and vice president of the International Council of Women. Perhaps her most significant contribution was the creation of the Political Equality Club of Ann Arbor. This group sued the city because women who paid local taxes were not allowed to vote locally. In 1881, the Michigan Supreme Court upheld the ruling in favor of the women. As a result, Bower also served as both treasurer and president of the Ann Arbor School Board.

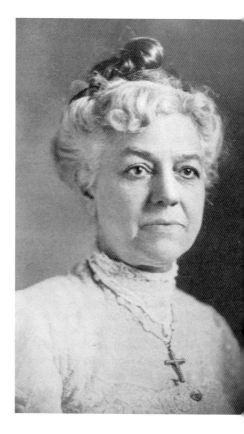

More Than a Nickels' Worth

One of Ann Arbor's most distinctive pieces of architecture is the Nickels' Arcade. It boasts a magnificent glass, arched roof that was so popular in Europe in the late 19th century. The area, which first had been a butcher shop, later became a sheltered walkway lined by shops. John H. Nickels came to Ann Arbor from England via Canada. He had apprenticed as a butcher in England, so he started a butcher shop in Ann Arbor. He married and fathered three sons. Thomas, the eldest, worked with his father in the shop until his father died. Then, the youngest Nickels, Stafford, joined his brother in the shop. Later, Stafford started an ice business. Eventually, Thomas purchased all of the adjacent property that belonged to his siblings and razed the market. He hired Hermann Pipp to design the corner bank building and the arcade. It was finished in 1918 and is now in the National Register of Historic Places. (Courtesy of the Bentley Historical Library.)

A Hard Life

Katherine Crawford was born and raised on Fuller Street in Ann Arbor. She completed her early schooling in Ann Arbor and graduated from the University of Michigan School of Medicine in 1898. What makes Crawford exceptional for her era is that she was African American. Her race and gender shaped her life, which was a constant struggle. She began her medical practice in Ohio but quickly returned to care for her mother. While in Ann Arbor, she continued practicing medicine. After 1911, Dr. Crawford worked in California and Florida. Eventually, she returned to Ann Arbor, but she was too ill to work. She died penniless in 1943. Despite all her challenges and disappointments, Dr. Katherine Crawford was a member of a very exclusive group. She was one of only 155 African American women licensed in the United States to practice medicine at the turn of the century. (Courtesy of the Bentley Historical Library.)

Versatile Valedictorian
George Jewett Jr. did not come from an affluent family. Being African American in the late 1800s was a decided disadvantage, but he took Ann Arbor and the University of Michigan by storm. Jewett graduated valedictorian of his class at Ann Arbor High School. He then matriculated at the University of Michigan School of Medicine. When he was not in class, he could be found on the football field, where he was the first African American to play

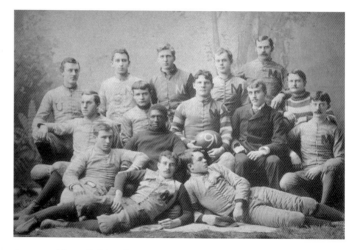

on Michigan's varsity team. Jewett is second from left in the second row of this 1890 team photograph. He did not just play; he was the leading rusher, scorer, and kicker. He was also the fastest sprinter in the Midwest. If there had been a Heisman trophy in the 1890s, he would have won it. Jewett left the University of Michigan transferring to Northwestern, where he also was a star football player. After practicing medicine in Chicago for a few years, he returned to Ann Arbor where he opened a service on State Street just north of the Union, which he called "The Valet." Dry-cleaning was just then gaining popularity, so it was an excellent choice for an occupation. He married and fathered two sons but died suddenly in 1908. He was only 38. (Courtesy of the Bentley Historical Library.)

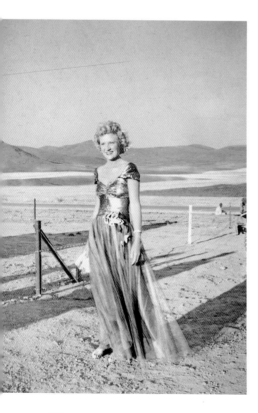

Wounded by the Truckload
Mildred Radawiec was a frontline nurse during World War II. In just 10 days, she left her position at the University of Michigan Hospital, postponed her marriage, put her affairs in order, and filled out Army paperwork in quintuplicate. She reported for duty as a US Army nurse with the 3rd Auxiliary Surgical Group and began a new career that took her to North Africa, France, Belgium, and Germany. Radawiec survived a harrowing ocean crossing and another difficult trip through the Sahara. She experienced air raids and buzz bombs; she witnessed the death of a fellow nurse. And she helped save the lives of soldiers at the Battle of the Bulge as well as victims of the Buchenwald Concentration Camp. Yet, through the horror, Radawiec and her outfit found time for a little levity and leisure. One such event took place in North Africa when she and other officers were invited to a party. In a silver lame dress that she bought in New York just before boarding the troop transport, she rode in style in the back of a military truck across the sands to an evening of trying to forget the truckloads of wounded who would be her patients. After her service, Radawiec managed to smuggle her adopted French poodle aboard the returning ship. Once back in Ann Arbor, she and Robert K. MacGregor were married. (Courtesy of the University of Michigan Press.)

A Lens on the World

Conrad G. Ganzhorn Jr. was born and raised in Ann Arbor. His dad was a fruit grower, but Conrad wanted to do something else. When he turned 19 in 1939, he trained at the Frankford Arsenal in Philadelphia. President Monroe established the Arsenal in 1816 as the munitions plant for the US Army. Over the years, it has provided munitions ranging from the musket to today's computerized and laser weapons. It was there that Ganzhorn learned to grind lenses. He was so skilled at lens grinding that he received a deferment from the World War II draft. He spent that war and many years after it working for Argus Camera in Ann Arbor. Founded in 1936, Argus Camera's Model A was the first low-cost 35 mm camera manufactured in the United States. But Argus quickly retooled itself to support the war effort becoming a major manufacturer of military equipment such as binoculars, rifle scopes, and Sherman tank sights. At Argus, Ganzhorn worked in the basement grinding and polishing lenses, which were washed in a horse trough of water. After World War II, Argus returned to manufacturing primarily cameras, and Ganzhorn returned to grinding camera lenses. (Courtesy of the Argus Camera Museum.)

Just Doing Her Job

Fresh out of Ann Arbor High School with the class of 1942, she decided to join the war effort and took a job at the American Broach & Machine Company. It was there that a United Press International photographer took Hoff's picture as she worked with her hair covered with a polka-dot bandanna. From that photograph, a Pittsburgh graphic artist, hired by the Westinghouse Company's War Production Coordinating Committee, created a drawing and then a poster that became the iconic image—the "We Can Do It!" poster. The woman in the drawing, Geraldine Hoff, became known as "Rosie the Riveter." J. Howard Miller's poster, originally to combat absenteeism and possible strikes within Westinghouse, was shown only to company employees in the Midwest during a two-week period in 1943. The poster lay dormant after that until it was revived during the women's liberation movement of the 1960s and 1970s. (Courtesy of Pioneer High School.)

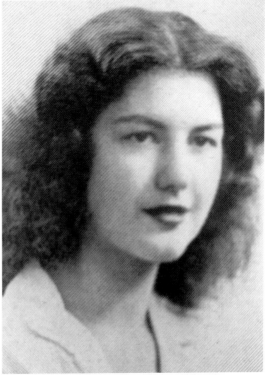

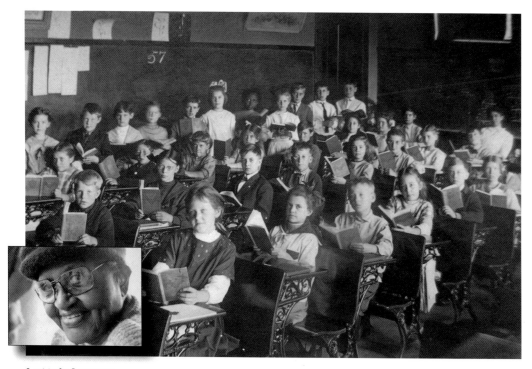

Letty's Legacy

Letty Wickliffe was born and raised in Ann Arbor. Her father, Joseph Holt Wickliffe, was an escaped slave who served in the Union army during the Civil War. Her mother, Mary, was a member of the Jewett family who came to Ann Arbor around 1854. Letty received her bachelor's of arts in 1924 and her master's of arts in 1930. Both degrees were from the University of Michigan. What made her stand out was the fact that she was African American. Pictured standing in the above photograph, she is the only African American in Tappan School's third-grade class. At the University of Michigan, she was one of six in her graduating class. Though Letty's professional career took her to Indianapolis where she was head of the Department of Exceptional Children at Crispus Attucks High School for 40 years, she returned to Ann Arbor when she retired in 1969. She and her brother Walter helped found the North Central Property Owners Association, for which she served as president. She also helped start the Citizens' Association for Area Planning. And she served on many boards such as those of St. Joseph Mercy Hospital and Dawn Farms. Wickliffe received too many local and national tributes to name them all, but one lives on for all to see. It is a condominium complex, named Wickliffe Place, between Fourth and Fifth Avenues north of Beakes Street. In the inset photograph, she is pictured as she looked during her days as a political activist. (Both, courtesy of the Bentley Historical Library.)

Quick As a Flash (OPPOSITE)

When Harvey Drouillard came to Ann Arbor from Port Huron in 1993, he was 29. Using only his first name, he lived downtown in a large open loft, which he turned into an art and music club he named "Anecdote" after a similar place in Port Huron. A year later, he borrowed a camera and shot his first roll of film. It was no surprise that it turned out blurred, but Harvey was not dismayed. Then, he met a graduate student named Mary Beth. They made a great team. They would find suitable locations for their photographs. It could be a coffee shop, a street corner, or even a university lab. What made Harvey's photographs, which he later sold as cards, unusual was that Mary Beth was nude. They were so quick that people standing or sitting quite close to Mary Beth remained unaware of what had happened. Harvey is still taking photographs 21 years later. (Courtesy of Harvey Drouillard.)

Riding the Waves

For nearly 56 years, he rode the waves in Ann Arbor—the radio waves. From his five-day a week, three-hour broadcasts to a two-hour show on Saturday afternoons, Theodore "Ted" Heusel, spread his talent among a number of local stations with talk, interviews, and editorials. He spent time as a disc jockey and created one of the earliest radio-call-in talk shows where listeners were not screened before contributing to discussions of political elections as well as

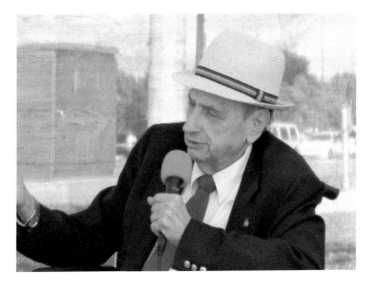

local issues and happenings. Heusel interviewed Paul W. Tibbets Jr., the B-29 pilot who flew the famous *Enola Gay* over Hiroshima. He also interviewed James Earl Ray, who assassinated Martin Luther King Jr. But he never forgot his hometown family and included mayors, local writers, and performers in his shows. He was a member of the Ann Arbor School Board, serving as its president for a number of years and helped to create the city's alternative high school. While he was doing all this, he remained active with the Ann Arbor Civic Theater, a calling that could have evolved from his teen years as an usher at the city's Michigan Theater. (Courtesy of Dan Martin and WAAM Radio.)

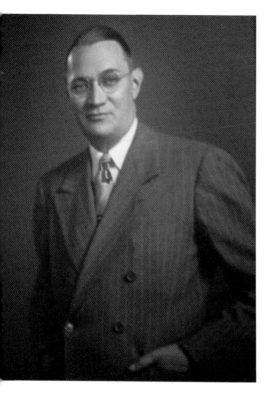

Just Say No

In 1959, the 70 acres north of Kingsley Street was home to 502 families. It was the area of town in which 70 percent of Ann Arbor's African American residents lived. It was where two congregations of African Americans had their churches. But it had become a bit dilapidated. The slaughterhouse and coal gasification plants permeated the neighborhood with foul smells, noise, and rats. City council decided something needed to be done. There were federal dollars available for urban renewal projects. Ann Arbor was approved for a grant of $1 million. For three years, the debate dragged on. Should the city bulldoze the entire area? So hot was the issue that, for the first time in history, council meetings were broadcast over the radio to inform Ann Arborites of the argument's pros and cons. With time running out to qualify for the federal grant, it came to a vote in 1959. Six council members were in favor of the destruction; five were not. Fortunately, for the North Central residents, Cecil Creal, who had just become mayor of Ann Arbor the week before, used his veto power as mayor to stop the proposed destruction. (Courtesy of the Creal family.)

What's Shakin'?

For almost 40 years, he reigned in downtown Ann Arbor. He told whopping tales, such as how, at age two, he hitchhiked from Little Rock, Arkansas, where he was born, to New Orleans. He played a guitar with only two strings and sang for tips. Shakey Jake Woods brought joy to Main Street. He always had a bright smile for passersby and a warm appreciation for those who dropped a coin or two into his open guitar case. Townies festooned their cars with "I brake for Jake" bumper stickers. He rode in the annual Fourth of July parade waving to the enthusiastic crowds on the sidewalk who would clap and wave and call to him as he passed by. Shakey Jake used to tell people that he was immortal due to some kind of voodoo magic. Sadly, he was not. He died in 2007 at the age of 82. Hundreds of locals came to his memorial service, which spilled out onto the streets of Ann Arbor with music and song. Shakey Jake would have liked that. (Courtesy of Rachel Holmes.)

Eight-Sided Beauty
This title might make readers expect a woman, but "eight-sided beauty" is the Chinese expression for what the West calls a Renaissance man or broadly talented person. It is a perfect description for Gabriel Chin, who was an interpreter, a singer, a poet, a calligrapher, a scholar, a healer, a tai chi master, and a chef. Chin met his wife, Janet, when she was a missionary in Taiwan. He liked to joke that if he dug a hole through the earth from his birthplace in Shandong, China, the hole would end precisely where she was born in Virginia. The Chins came to Ann Arbor so that Gabriel could get a graduate degree. They planned to return to Taiwan, but they never did. Gabriel had several occupations. He interpreted for local courts since he spoke various dialects of Chinese. He taught at the Sun Shen Chi Clinic, but he is better known for his cooking. Ann Arborites would hire him to cook a Chinese banquet for them and their guests. Chin also did all the cooking for his wife and four children. His most visible activity was leading tai chi by the Cube. Chin passed away in 2005, but Chad Eisner has continued the tradition of Sunday morning practice at the Cube. "As long as people attend," says Eisner, "Chin's legacy will live on." (Courtesy of the Peter Yates Collection, Bentley Historical Library.)

Namaste

Barb Linderman (pictured) was 74 when she passed away in 2007, but her presence continues to influence her students. Barb did not just teach yoga; she modeled a way of life that exuded health and serenity. After growing up near Cleveland, she and her husband, Gerry, spent their first 10 years together in the Foreign Service. They were stationed in Nigeria, India, and the Congo. It was in India that Barb discovered the physical and psychological benefits of yoga. They returned to the United States so that Gerry could finish his doctorate at Northwestern. Then, in 1969, they came to Ann Arbor, where he became a history professor at the University of Michigan. In 1969, yoga was not a common form of exercise. Barb had introduced some yoga asanas to a fitness class she taught in Evanston, Illinois. The next term, she taught a class that was only yoga. It was so well received that she returned to Evanston once a month for six years to lead a full-day workshop. In the early 1970s, Swami Pranananda introduced her to the more spiritual side of yoga—*pranayama* (breath) and chanting, which is meditative. Then she did what all gifted teachers do: she put what she had learned into a brand-new approach. There were those who disagreed with her new method, but she persisted. She practiced yoga to chants which calm the spirit and regulate the breath so that both the body and the soul benefit from the practice. Finally, in 1995, she formed a group called Inward Bound. Classes are held at the Friends' Center on Hill Street, which has preserved her extensive library of books related to yoga, meditation, and spiritual healing. (Courtesy of Gerald Linderman.)

A Community Treasure

Cathi Duchon, chief executive officer of Ann Arbor's Y, called Coleman Jewett "a treasure." Most people in Ann Arbor would agree. Coleman was George Jewett's grandson. He followed in his grandfather's footsteps by graduating from Ann Arbor High School, where he was student council president. Coleman also excelled in sports, including football, basketball (No. 27), and track. His boxing practice earned him the Michigan Golden Gloves middleweight championship. Jewett received both his undergraduate and graduate degrees from Eastern Michigan University, which, in 1953, was still called Michigan State Normal School. All of that preparation plus a generous soul allowed him to contribute in many ways to the community. His day job was teaching. Later, he became assistant principal of Tappan Middle School and, finally, principal of Forsythe Middle School. At Tappan, he established a basketball league. The only criteria for joining was that all players had to be five feet and five inches tall or less. Then, he organized some of the first youth programs at the Y. Coleman Jewett retired in 1988. From then until his death in 2013, he could be found at the Washtenaw Dairy, drinking coffee and hashing over the news with all the regulars. If he was not there, he would be at the farmers' market where he sold his woodworking. Adirondack chairs were his specialty. If both of those searches failed, he was probably at home with his wife, Maggie. (Courtesy of Carol B. Smith.)

Fairy Tales

In 1993, something amazing occurred. A fairy door appeared in the west-side home of Jonathan and Kathleen Wright. Perhaps the fairies selected the Wright home because of Kathleen Wright's Irish background or because the fairies knew what a wonderful preschool teacher she was. Or perhaps the fairies came because of Jonathan Wright. The name Wright is a perfect one for him because it means someone who makes things. Jonathan is an illustrator and designer of products for children. It was not until 2005, however, that the fairies returned. This time they selected a public place, Sweetwater's on West Washington Street at Ashley Street. Since then, the fairies have been very busy. Fairy doors are popping up all over Ann Arbor and have expanded into neighboring communities. No one has ever seen the fairies, because fairies only come when no one is around. (Photogaph by Susan L. Nenadic.)

Purr-Fectly Wonderful

Lewis the cat adopted Ann Arbor's Downtown Home and Garden store and its employees and customers in 1999. Sometimes referred to as one of the city's "fattest cats," Lewis reigned over the store for nearly 15 years. He often watched from a bench where he liked to stretch out. During cold Michigan winters, he preferred a place next to a radiator. In summer, he often chose a sunny spot in the store's front window. He became an Ann Arbor celebrity. Upon Lewis's death in 2014, Mark Hodesh, owner of the store, posted the following

obituary for him on Facebook: "He enjoyed a brilliant career here over the years allowing children to maul him with kisses, and gently taught them when enough is enough. He indulged foolish baby talk from some adults while keeping a knowing, dignified relationship with others." Though gone, Lewis will live on in Beth Johnson's book *Lewis the Downtown Cat*. (Courtesy of Beth Johnson.)

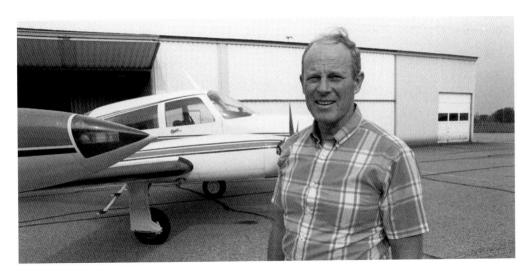

Ann Arbor Astronaut

Eleven NASA astronauts have been graduates of the University of Michigan. All three pilots on the Apollo 15 mission studied at the university; however, only one was a real Ann Arbor townie. That was Jack Robert Lousma. He was born in 1936 in Grand Rapids, Michigan, but came to Ann Arbor as a boy. He attended Angell, Tappan, and Pioneer before entering the University of Michigan in 1954. Lousma studied aeronautical engineering and joined the Marines. Six years after he earned his aviator's wings in 1960, he was chosen by NASA to be one of the 19 men trained as astronauts. As the support crew for Apollo 9, 10, and 13, he was the one who received Apollo 13's famous transmission, "Houston, we have a problem." In 1973, Lousma had his opportunity to be on the space side of the transmissions as pilot for Skylab 3. More missions followed. All totaled, Lousma spent more than 1,619 hours in space. (Courtesy of the Peter Yates Collection, Bentley Historical Library.)

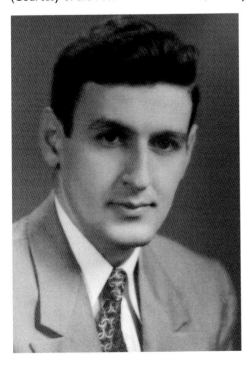

Enough Is Enough

Merian Brown Frederick loved life. She was active in sports. She protested the Vietnam War and promoted Amnesty International and Common Cause. She and her husband, Julian, had seven children. Life was good until she was diagnosed with Lou Gehrig's disease. A person with this disease is ultimately trapped in his or her body, which no longer functions and, eventually, suffocates. Before she became totally trapped in her own body, Merian made the informed decision to contact Jack Kevorkian (pictured). Having graduated from U-M for both his undergraduate and medical degrees, he medically assisted in her death on October 22, 1993. She did this with the support of her family and her minister. Dr. Kevorkian was arrested, but the charges were dismissed. It was his 19th assisted suicide. People who knew her formed a lobbying group called Merian's Friends. The group, led by Dr. Edward Pierce, tried to have a law passed in Michigan that would allow for euthanasia. They failed. (Courtesy of the Bentley Historical Library.)

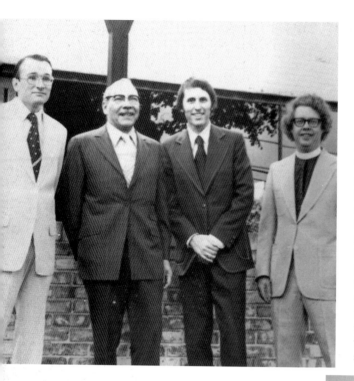

A Wonderful Partnership

In 1974, the new St. Clare's Episcopal Church had been built on Packard Road and had a new rector, Doug Evett. Meanwhile, Beth Emeth's Rabbi Bruce Warshal was leading his small but growing flock in rented space at First Congregational Church and the Unitarian Universalist Church. When Reverend Evett (right) met Rabbi Warshal (second from right), an immediate bond was formed. Instead of Temple Beth Emeth renting space from St. Clare's, the two groups entered a legal partnership called Genesis of Ann Arbor. Bob Creal (left) led the committee that created the bylaws. Four members of each congregation serve on the board. They have coexisted harmoniously for more than 40 years. Mayor Wheeler (second from left) stopped by to celebrate the alliance. (Courtesy of Genesis.)

Beat This

Known to Michiganders as "Mr. Democrat," Neil Oliver Staebler has a record hard to beat. He worked for the US Office of Price Administration and was a member of both the Democratic National Committee and the Democratic National Convention from his home state. This Ann Arbor native served in the US Navy, as a representative in the US Congress, and as a member of the Federal Election Commission. Such activities were carrying on a family legacy. His father, Edward, was once mayor of Ann Arbor as well as a coal dealer, oil distributor, and automobile dealer. Neil absorbed his father's sense of business and community. When he returned to Ann Arbor after World War II, he began building Lustron houses. These were prefabricated enameled steel houses that could be erected in a week, just right for the hordes of veterans returning from the war. Staebler had learned about these houses while working for the Federal Housing Administration. He obtained a franchise and was able to build nine Lustron houses in Ann Arbor before the manufacturer went out of business. "I thought they were a swell idea," Staebler said. "Lustron promised to be a durable material, which it has proved to be." All nine houses remain in use in Ann Arbor. (Courtesy of the Bentley Historical Library.)

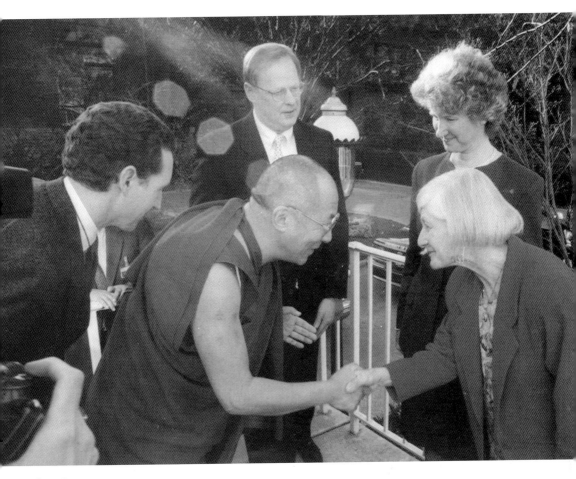

Survivor

Irene Hasenberg Butter's name is not a household name in Ann Arbor, but it should be. She certainly is known among local schoolchildren because of her visits, sharing her life story. Irene was born in Berlin, Germany. Her family moved to the Netherlands in the 1930s when she was six. Her father thought the family would be safe there. They were not. Like so many Jews, they were sent to Bergen-Belsen concentration camp, where she collected clothing for Anne Frank. But when she threw the bundle over the wire fence, other inmates grabbed it first. Her family was more fortunate than Anne's. They acquired false Ecuadorian passports and were exchanged for German citizens residing in Allied countries. The exchange took place in Switzerland. Irene's father died during the four-day train journey, yet Irene Butter never sees herself as a victim of Nazi oppression. She calls herself a survivor. Irene not only survived—she thrived. She obtained an education that culminated in a doctorate in economics and, subsequently, taught at the University of Michigan for 35 years. She married and had two children. But her lasting gift to Ann Arbor has been her work with the Wallenberg Project. Irene Butter has been instrumental in the establishment of U-M's Raoul Wallenberg Award. Recipients have included Elie Wiesel, the Dalai Lama, Miep Gies (who hid Anne Frank's family), and Paul Rusesabagina. Equally significant is a group she cofounded called Zeitouna, which means "olive tree" in Arabic. Comprised of six Jewish women and six Palestinian women, the group refrained from talking politics for a year. Instead, they learned about each other. Dr. Butter is not interested in blame, but she does feel everyone has a responsibility to make the world a more peaceful and kinder place for everyone. (Courtesy of Irene Hasenberg Butter.)

CHUCK MUER'S GANDY DANCER RESTAURANT & ROUNDHOUSE SALOON KEMNITZ

Artistic Rabble-Rouser

Many young Ann Arborites believe social protest began in the 1960s. And many older Ann Arborites think of Milton Neumann Kemnitz as just an artist who did lovely images of the city. But he was much, much more than that. Born in Detroit in 1911, Kemnitz graduated from the University of Michigan at the beginning of the Great Depression. He was fired from his first job as a social worker for Washtenaw County because he organized the welfare recipients in an effort to improve their benefits. That pretty much defines the first half of Kemnitz's career. He joined the National Federation for Constitutional Liberties and organized the 1942 National Action Conference in Washington, DC, where they protested Japanese American internment, Jim Crow laws, and suspension of the right to strike during wartime. It was during World War II that he learned to paint. In 1947, he returned to Ann Arbor with his family and began his second career as an artist. But he could not stray too far from social protest, so he used his paintings to fight for preservation of old buildings, such as the train depot pictured above. He also participated in many local projects from which residents today benefit: Birds Hills Park, the Food Co-op, and the Ann Arbor Art Association. For all his contributions to Ann Arbor, the mayor declared a day in 1974 to be "Milt Kemnitz Day." (Courtesy of the Bentley Historical Library.)

CHAPTER SIX

The Kindness of Strangers

In January 2011, a man identifying himself only as W.F. wrote to St. Andrew's Episcopal Church thanking parishioners for their "love, kindness and everything that went along with the refuge that I received in my time of need." He continued by saying that they had found it in their hearts to donate their time and money (and prayers) to not only participate in the rotating shelter program but to provide a hot breakfast each morning. "Through your example, I feel like things are already better."

St. Andrew's is by no means the only group to recognize the need for programs to support the less fortunate. Many state institutions closed leaving their clients literally out in the cold. Such people needed housing, food, advice, and, in some cases, treatment. The people of Ann Arbor have responded through a variety of programs.

Before the Delonis Center opened, local churches welcomed the homeless during the winter. Avalon, which began with one house for just a few folks, now provides many apartments and houses. The problem of food has been answered by the Breakfast Program, Food Gatherers, Meals on Wheels, and Backdoor Pantry. Abused women and children find refuge at Safe House, while marginalized teenagers discover a warm welcome at Ozone House and the Neutral Zone. Several excellent thrift shops provide inexpensive clothing and household items. All of these programs, each in its own way, are widely supported in the community. Residents donate hundreds of hours of their time to provide support for people in crisis so that they, like W.H., can feel better about themselves and their lives.

Ann Arbor Abolitionist

Michigan was an integral part of the abolition movement before the Civil War, and Guy Beckley was one of the most pivotal individuals in that movement. Not only was his home at 1425 Pontiac Trail a way station for the Underground Railroad, but he also participated in the November 1836 Antislavery State Convention, which was held at the First Presbyterian Church in Ann Arbor. The Michigan State Antislavery Society and a weekly newspaper called the *Signal of Liberty*, coedited by Beckley, resulted from that meeting. Beckley printed the newspaper above his mercantile store. The paper only lasted a few years—probably because Reverend Beckley died in 1847, but it boasted 2,000 subscribers, with many being outside of Michigan. The May 12, 1841, issue of the *Signal of Liberty* remarked that six "friends" [runaways] had been the recipients of hospitality before leaving 16 hours later for a land of freedom": Canada. (Both, courtesy of the Bentley Historical Library.)

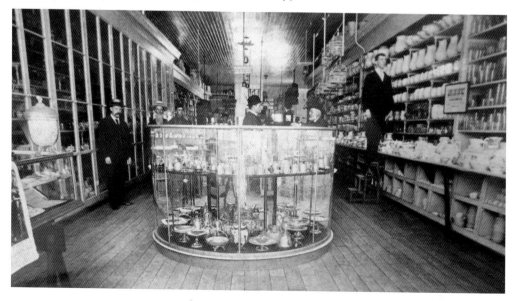

Life of Service

The mortal remains of Ashley Hubert Clague reside in Bethlehem Cemetery, but the spirit of the man can be found throughout Ann Arbor. Clague Middle School, named for him, finds its words of inspiration in his motto "Live in service to our community." Clague was a "Yooper" (from the UP or Upper Peninsula) with a sixth-grade education when he arrived in Ann Arbor in 1922. Four years later, he started a grocery store on Packard Road. He later claimed he did not need a sign; everyone knew what it was. And they did. However, it was not the store that made Clague legendary. He participated in so many civic groups that it is impossible to name them all. He was a member of the school board for 20 years; for 15 of those years, he was president. It was in that capacity that he rolled up his sleeves after the ground-breaking for Pioneer High School and took a spin on the earthmover. For 18 years, he was a member of the Kiwanis committee for crippled children. For 19 years, he was Ann Arbor's park commissioner. He fought for more new schools and Veterans' Memorial Park. He also was president of the Washtenaw County Muscular Dystrophy Association. He made 500 games for the children at University Hospital. It is certainly easy to see why a school was named for him. Ashley H. Clague serves as a role model for the middle school students and the entire community. (Courtesy of the Clague family.)

Tree-Town Benefactress (OPPOSITE)

Ann Arborites refer to their city as "Tree Town." It seems a natural thing to say, since "arbor" refers to the oak opening that its original settlers found so inviting. It is a nice theory, but some of the credit really belongs to Elizabeth Russell Dean. Her father, Sedgwick Dean, and his brother Henry Stewart Dean opened a store after the Civil War. Dean and Company (pictured) originally sold china; however, later it stocked cheeses, citrus fruits, tobacco, as well as barrels of flour, sugar, cornmeal, molasses, and vinegar. They also carried toys, but it was Sedgwick's love of coffee that gave the store its popularity. He roasted the beans in the store, thus providing shoppers with a wonderful aroma. The brothers invested in other businesses such as the Argo Mill, which helped make them rich. Born on Christmas Eve 1884, Elizabeth lived her entire life in Ann Arbor. When she died in 1964, she left her estate of almost $2 million to the city of Ann Arbor to plant and maintain trees in perpetuity. Her cousins challenged the will, but the court upheld the bequest. (Courtesy of the Bentley Historical Library.)

Postman's Rest

On the corner of Vinewood and Wayne Streets in southeast Ann Arbor, there is a tiny park. In fact, it is Ann Arbor's smallest park. It is a wooded corner lot with a curved sidewalk and a pleasant bench. Before 1965, it was the home of Mrs. Frederick Mueller. She and her husband were one of the first couples to live in that neighborhood. Mrs. Mueller, née Charlotte Agnes "Annie" Belger, left the property to the city when she passed away. A 1903 graduate of the University of Michigan, Mueller was a journalist. The *Ann Arbor Times News* hired her after she obtained an interview with a professor who "never gave interviews." She also wrote a column for the *Detroit News*. So why is the park not named Mueller Park instead of Postman's Rest? That is the best part of the story. Mrs. Mueller, widowed since 1937, lived alone. She had no family to care for her as she aged. Knowing that, her postman Norm Kern stopped by each day to check on her. When Kern retired, his replacement Bob Schlupe did the same. The park was established as a thank-you to Kern and Schlupe, who went well beyond just delivering the mail. (Photograph by Susan L. Nenadic.)

Venture Capitalist

Most people know Amherst "Nub" Turner as the founder of GT Products, Inc. Turner borrowed $7.5 million in 1983 to purchase the King-Seeley Plant, the last remaining factory in downtown Ann Arbor. Not only did he save a historic building, but he also provided employment for over 200 people. Born and raised in Ann Arbor, Turner received his bachelor's of arts in English from the University of Michigan in 1961. Between then and the founding of GT Products, he served as a captain in the military and worked as sales manager of Chrysler's Introl Parts Division. Turner sold GT Products to Eaton in 1998. Eaton kept the business but sold the building in 2004. It is now Liberty Lofts. Turner then began Amherst Funds, LLC, Venture Capital and Private Equity. In addition to serving on many boards of directors, such as the Ann Arbor State Bank, Turner and his wife established the Amherst and Janeth Turner Foundation. (Courtesy of the Peter Yates Collection, Bentley Historical Library.)

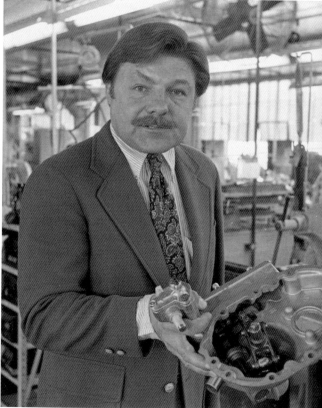

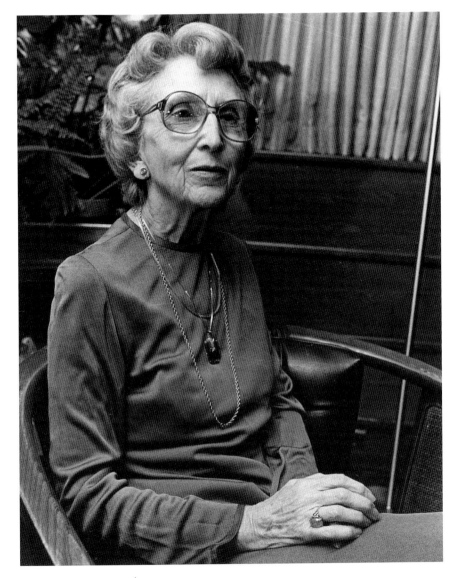

A Generous Heart

One cannot be in Ann Arbor very long without bumping into the name of Margaret D. Towsley. She founded Towsley Children's House and led the effort to create a gender-integrated Y. Her generous contributions helped build Schembechler Hall, a performance space within the School of Music and the Center for the Education for Women. These are only a sampling of the beneficiaries of Margaret Towsley's generous support. Margaret graduated from the University of Michigan in 1928 and received a master's in education from Columbia two years later. She met her husband, Harry, at Michigan, where he graduated from the School of Medicine and later became chair of graduate studies in medicine. She was elected to the Ann Arbor City Council twice, making her the first woman to serve in that capacity. In 1959, Margaret established the Towsley Foundation, which began promoting education, health, and shelter for children. It later included gifts for higher education, Planned Parenthood, and interdisciplinary programs for law and social work. How was she able to support so many good works? The initial "D" in her name is the clue. Margaret came from Midland, Michigan, where her father, Herbert Dow, founded the very successful Dow Chemical Company in 1898. (Courtesy of the Bentley Historical Library.)

St. Andrew's Angel

For 27 years, Svea Gray rose before dawn and went to St. Andrew's Church on Division Street. She was not going to religious service in the traditional sense; she was going there as director of the Breakfast Program to serve food to the impoverished population of Ann Arbor. Gray's father came from Sweden, so he named her Svea, which means Sweden. In 1957, she graduated from the University of Michigan, where she studied music and met her future husband, Whit. Whit left for Paris to study international law. The next summer, Svea and her aunt toured Europe. They stopped in Paris. In a picture-perfect, romantic moment while gliding down the Seine in one of the Bateaux Mouches, Whit proposed. And they have been together ever since. Returning to Ann Arbor in August 1982 just a week or two after the Breakfast Program began, Svea immediately volunteered. She then attended Princeton Theological Seminary, was ordained to the diaconate in June 1985, and joined the staff at St. Andrew's, where she became the director of the Breakfast Program. In the early 1980s, Michigan had one of the highest unemployment rates in the United States. Recognizing the need, the program began with just a few volunteers and 35 guests serving breakfast three times a week. It quickly mushroomed into 150 guests served every day of the week by over 100 volunteers, many of whom were not parishioners. "Sister Gray" retired in 2012, but the Breakfast Program, which she so successfully led, remains. (Photograph by Susan L. Nenadic.)

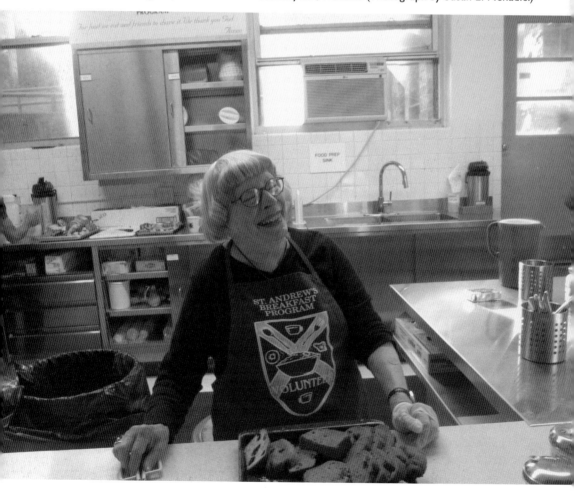

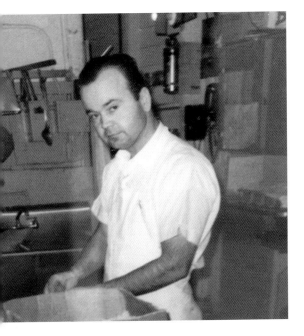

Holiday Hospitality

When it opened in 1948, the Cottage Inn became the first in Ann Arbor to serve pizza. Now at the local chain's flagship restaurant on East William Street, it sets aside its usual Greek and Italian specialties to serve turkey and dressing—available one day only—and it is at no charge, free. More than 30 years ago, Nicholas Michos began serving a free Thanksgiving Day Dinner to anyone who wanted to come through his restaurant's door. Staffed with local volunteers, the restaurant serves about 350 holiday meals. These meals include the traditional turkey, side dishes, and desserts all served on linen-clad tables. When Nicholas died in 2014, there was no question whether the family-run business would continue his custom of giving back to the community. They have, and they will. (Courtesy of Cottage Inn.)

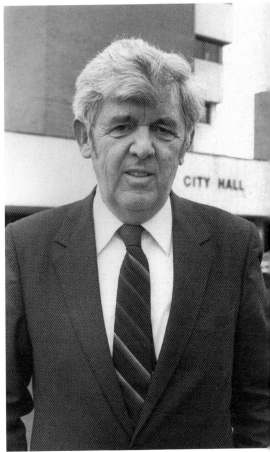

What's Up, Doc?

Dr. Edward Pierce was a man of diverse passions. He was born in Three Rivers, Michigan, but came to Ann Arbor when he was 10. He graduated from the University of Michigan first with a bachelor's of arts in 1955 and then his doctorate of medicine in 1959. For eight years, he had a family practice, but in 1968, he started the Summit Medical Center. What made the center unique was that it did not charge patients who could not pay for medical care. Dr. Pierce's second passion was politics. He served on the Ann Arbor City Council and then in the Michigan Senate. In 1985, he was elected mayor of Ann Arbor. In 1969, Dr. Jerry Walden, who had recently graduated from the University of Michigan School of Medicine, joined Pierce at the Summit Medical Clinic. He remained there until 1973, when they received a $50,000 federal grant to open a second clinic on Packard Road near Platt. The Packard Community Clinic's waiting room is always full. As a 501(c)(3), it operates on a pay-what-you-can basis. Dr. Walden was named Family Physician of the Year in 2000 by the Michigan Academy of Family Practice. (Courtesy of the Bentley Historical Library.)

Crisis in the City

In the 1980s, Ann Arbor faced a growing crisis: homelessness. Local churches and volunteers came together to form the Shelter Association of Washtenaw County to meet this problem head-on. A house was rented, citizens volunteered various services, and an average of 25 people a night slept on mats on the floor. Then, another building was purchased and renovated. In 1997, Robert J. Delonis, chairman of Great Lakes National Bank (now TCF Bank), stepped forward as the community's first business leader to head the charge against the increasing need for shelter and solutions to the basics of the problem. Various individuals and organizations followed Delonis's lead, ultimately raising the millions of dollars to build a new shelter and consolidate services. The county commissioners approved naming the new shelter in honor of Delonis, "whose inspiring commitment to the Shelter Association turned the dream of a new shelter into reality." Unfortunately, Delonis did not live to see the dream fulfilled. Now, approximately 3,880 adults a year are served in the temporary residential program. When temperatures plummet to 10 degrees, another 150 to 200 can find refuge in the building's dining room. Food Gatherers, one of the center's many community partners, serves 20 meals a week there. (Photograph by Susan L. Nenadic.)

Comfort and Care

Today, we expect health care services such as hospice, but it was not too long ago that hospice did not exist. Terminally ill patients usually stayed in the hospital or a nursing home, which had equipment and pharmaceuticals to ease the patient's discomfort. Patients' homes gave them emotional well-being but lacked the professionals' ability to provide physical relief. None of those choices seemed adequate to Mary Lindquist, who was a wife, a mother, and a nurse. She believed the dying should have both physical and emotional support. Her husband, George, agreed; so in 1984, she founded a nonprofit called Personalized Nursing Service (PNS), which had a staff of three nurses, a bookkeeper, and a board of directors. Four years later, PNS received certification from Medicare. In 1990, PNS launched a campaign to build Michigan's first licensed in-house hospice facility. It opened in 1998. Since then, Arbor Hospice has expanded by adding facilities in other southeastern Michigan cities. Today, patients can have the best of both worlds. They can stay at a hospice facility or at home where trained home-care professionals can attend to their needs. (Courtesy of Ann Arbor Hospice.)

Home Sweet Home

Four decades ago, the state of Michigan closed its mental health hospitals. Patients had nowhere to go. The result was a staggering rise in homelessness. Toss into the mix Michigan's economic troubles, and there was a rise in homelessness for low-income families. It was a social crisis to which concerned citizens responded. Both the Washtenaw Housing Alliance and the Shelter Association contributed, but it was not enough. In 1992, after a year of planning, Avalon, led by Carol McCabe, was born. McCabe, originally a New Yorker, received a master's in social work from the University of Michigan. She had experience with VISTA (Volunteers in Service to America) and Safe House. Coming from that background, she recognized the problem but envisioned an atypical response. Many professionals think that treatment should precede housing; McCabe and Avalon supporters believe a safe place to live must be the first step. Only when that basic need has been met can Avalon assist with services such as eradicating dependencies and maintaining employment. McCabe's learning curve was steep since being a landlord or property manager was not part of her social work training, but she was a quick study. Today, Avalon owns 260 apartments and provides services to more than 600 adults and children. McCabe (right) is pictured here with Avalon's first board president, Jane Barney, in front of a duplex Avalon purchased in the 1990s. (Courtesy of Carol McCabe and Avalon.)

Teen Mecca

Emily Dengiz graduated from Pioneer High School is 1998. In school and out, she often saw young people behaving in inappropriate ways. She asked her mother, Lisa, why. The answer was that teens had nowhere to be. Emily told her mother that they needed to do something to alleviate the problem, and that is exactly what they did. First, they spent a year researching teen centers. What they learned was that centers throughout the country had not met with success. Undaunted, the mother and daughter believed such failures were because teens were not actively involved. Ann Arbor would be different. Meanwhile, Emily was a member of the Ann Arbor Community Foundation's Youth Council. She wrote a grant for a teen center and received $6,000 from the foundation. With that, the Neutral Zone (NZ) opened its doors on South Main Street. The grant money did not buy a lot, but it was enough for the rent and a few pool tables. The teens built a stage and were able to salvage some booths from a restaurant that was closing. Today, NZ is located downtown on Washington Street. It is a hive of activity. Teens still can find tutoring after school, but there is so much more. NZ has its own recording studio, one of the only ones specifically for teens in the country. Concerts and dances fill the "B-Side" (as in a record's side opposite of the featured song) for teens. For her efforts, Emily was named Young Citizen of the Year. There was no award for Lisa, though she certainly deserves one. Through the efforts of both mother and daughter, Ann Arbor has a teen center that breaks the stereotype because it is an unqualified success. (Courtesy of the Dengiz family.)

Leave It to Mom

With children in the Ann Arbor schools, Ann Holt was getting tired of her offspring being used as salesmen for the school system. Each year, they came home peddling to relatives, neighbors, and friends everything from holiday wrapping paper and candles to cookie dough. Holt decided to raise funds with periodic "garage" sales staged by volunteers from a small number of schools. The idea soon morphed into a real store with support from the local PTO council and school superintendent and began supporting all Ann Arbor schools. Staffed at first by volunteers and changing location four times, including once because of a fire, what has become the Ann Arbor PTO Thrift Shop is now open seven days a week. As her children graduated, Holt retired from the thrift shop. The nonprofit is now operated with a paid staff supported by volunteers. Today, the shop has revenues of approximately $300,000 a year from the resale of everything from furniture to books, clothing, and craft supplies. After expenses, the shop donates $100,000 to programs in Ann Arbor's schools. (Both photographs by M. Joanne Nesbit.)

Our Cup Runneth Over

Paula Dana is the living embodiment of kindness to strangers. Whether they be volunteers or patrons, each is welcomed with a genuine smile and inquiry as to how life might be treating them. She always listens patiently to whatever answer is given. Paula (right) served in the Peace Corps in Africa for four years. There, she used her certificate in veterinary science from Michigan State University to improve livestock practices. For her second stint with the Peace Corps, she organized tribes to cooperate in the building of a hydropowered gristmill. By the time she returned to the United States and Ann Arbor in 1992, she knew what kind of job she preferred. It was obvious to Paula that there was a common theme to her work: the alleviation of hunger. So it was natural that when Food Gatherers opened its Community Kitchen in the new Delonis Center, she became one of two paid staff who, with the help of over 100 volunteers, such as veteran Sue Caumartin (left), provide two meals a day every day of the year for up to 175 people. To cook at the kitchen requires some imagination, because all the food is donated. Sometimes, cooks are challenged by the lack of some essential ingredients, such as onions. Cooks just look at the supplies and find a way to put it together. This is not a soup kitchen. Meals consist of meat, carbs, salad, vegetable, dessert, and hot and/or cold drinks. (Photograph by Susan L. Nenadic.)

CHAPTER SEVEN

Businesses

"Go west, young man; go west." Credit for this famous piece of advice is usually given to Horace Greeley, editor of the *New York Tribune*. He used it in an editorial in 1865. The phrase actually originated 14 years earlier when Indiana journalist John B.L. Soule used it. The source, however, is less important than the quotation's meaning. American pioneers since they first arrived on the Atlantic shoreline moved ever westward in search of opportunities. Historian Frederick Jackson Turner believed that the development of the United States as a global power evolved from constantly taking advantage of the open land to the West.

Pioneers who came to Ann Arbor were well aware of the economic opportunities the ever receding frontier offered. John Allen and Elisha Rumsey knew this decades before Frederick Jackson Turner published his thesis. When recording their claim to what is now Ann Arbor in 1824, they did so as land speculators. It was a gamble, but it paid off. With a shortage of available farmland in the East, southern Michigan provided an opportunity that was impossible to resist. Roughly 25 percent of Ann Arbor's early settlers came from the state of New York, and many of those already had moved to New York from the New England area. Europeans also heard of the advantages this area offered. That is why so many emigrated from Germany, Ireland, and Italy. All of those people needed products and services. At first, they needed gristmills and sawmills. They needed farm tools and leather goods. What is amazing is that it took less than a decade before Ann Arbor businessmen and women began selling nonessential products like bonnets and lace from the East Coast and Europe.

Mozart Comes to Ann Arbor

Emigrating from Italy at three, mysteriously kidnapped, and taken to sea at nine, he never found his parents again. As an adult, Donald J. Mozart followed his father's profession as a watchmaker and then explored clock design and held several patents. In 1867, Mozart opened a jewelry store in Ann Arbor and established a watch company to produce his invention, a three-wheel watch. Touted as a mechanical marvel, the watch was what future manufacturers would call "self-winding." The Mozart watch showed quarter seconds, seconds, minutes, hours, days of the week, days of the month, and year. He gathered investors, rented a factory for tool making, and hired machinists. Officially incorporated in 1869, the machinery was moved into all three floors of the south side of Dr. Chase's Steam Printing House at Main and Miller Streets. By 1870, Mozart had completed 30 watches, but none of them sold. Those 30 watches were given to stockholders and friends. But after three years with nothing to show for their investment, the stockholders decided to sell the company. Various investor groups bought the company, renamed it, and moved it first to Illinois and then back to Michigan. All failed, and no more three-wheeled Mozart watches were manufactured. But success has come for Mozart and his watch long after the inventor's death. Collectors have been scouring shoe boxes, attics, and bank vaults from California to Connecticut to find a coveted Mozart watch described by collectors as "18s key wind, set from the back, three quarter plate, gilt and cased in gold-filled Ladd hunting cases." A unique American design. (Courtesy of the Washtenaw Historical Society.)

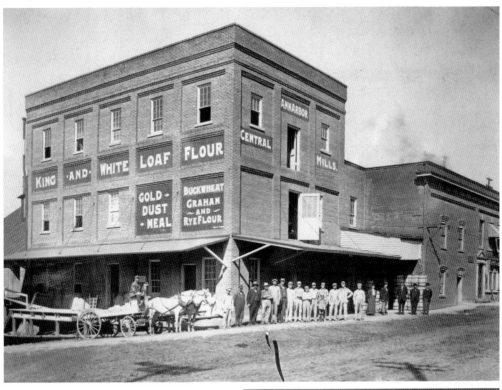

Milling and Music

There were many Allmendingers in Ann Arbor. They were a large extended family of German immigrants. The most famous was David F. Allmendinger, who established the Allmendinger Organ Company. The company employed 12 men who made 75 organs in only nine months. What most people do not know is that David began that company with his cousin G. Frank Allmendinger (right). Frank was born in New York in 1855 but spent his childhood in Ann Arbor with his grandparents because his mother died when he was an infant. He earned a degree in civil engineering from the University of Michigan in 1878, but it does not appear that he ever used it. Instead, Frank established the Central Flour Mill on First Street. Eventually, it became known as the Ann Arbor Milling Company. In 1900, local mill owners consolidated into the Michigan Milling Company for which he served as secretary and treasurer. Allmendinger also was a member of the University Musical Society Board of Directors for 38 years. (Above, courtesy of the Bentley Historical Library.)

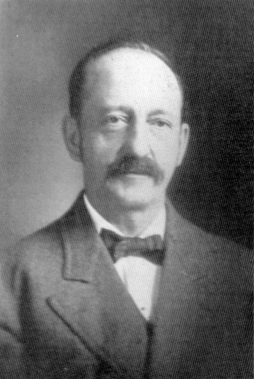

Nose for News

Samuel Beakes was born in New York in 1861. He studied at the University of Michigan for two years, 1878–1880. Then, he returned to New York and managed a pharmacy. He returned the following year to study law at U-M. After that, Beakes began his law practice in Ohio. It was there that he became interested in newspaper publishing. After a trial run in Adrian, Michigan, he came to Ann Arbor, where, in 1886, he bought the *Argus*, increasing the paper's circulation from 700 to 2,000 subscribers. In addition to his newspaper, he served two terms as mayor and one as city treasurer. But to any historian, Samuel Beakes's finest contribution is his book *Past and Present Washtenaw County*, which includes articles and photographs of significant Ann Arborites. Beakes's book, published in 1906, is a wonderful source for local research. In recognition of all his accomplishments, the city named a street after him. Beakes Street runs from the Broadway Bridge to Main Street. Appropriately, its terminus is at the site of the Washtenaw County Historical Society's Museum on Main Street.

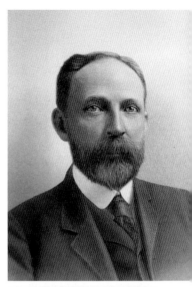

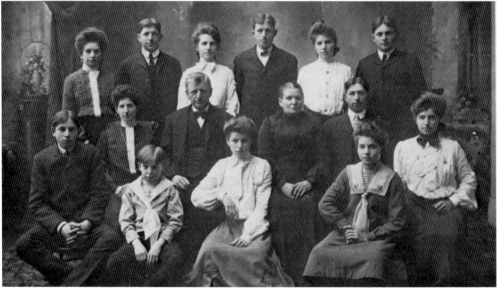

Three Brothers and a Sister

For more than 100 years, the building at 210 South Ashley Street has been an Ann Arbor fixture. It began in the 1890s when the building was constructed to house George Mann and John Zeeb's Grain Elevator. That business offered primarily feed, seed, and poultry grain. In 1906, Gotleib and George Hertler left the family farm north of Milan and moved to Ann Arbor. They purchased the building in 1906 with the intention of operating a livery, but because of the emergence of automobiles, the timing was wrong. So, they changed their plan and created a farm supply store. Later, their younger brother Herman and their sister Emma joined them. Hertler Brothers became more than just a place to purchase supplies. It was a meeting place where people swapped bits of news. The Hertlers also hosted euchre nights for anyone who cared to come. Almost 70 years later, Hertler Brothers was being run, ironically, by a Hertler sister, Emma (front row center). Her brothers, Herman, age 94; and Gotleib, age 102, were too elderly to help. Finally, in 1975, 89-year-old Emma decided it was time to sell and retire. (Courtesy of the Bentley Historical Society.)

Hearts and Flowers

In 1873, William Cousins married 16-year-old Lillian Eliza Hall from Barry County, Michigan. Soon after their marriage, they moved to Ann Arbor where they opened a greenhouse on South University Avenue at the site of the current U-M School of Social Work. Eliza and her brother John H. Hall also worked there. Despite the death of William in 1890, each year the business grew. Cousins and Hall Florists hired James Brogan to deliver the flowers. James Brogan's influence went beyond just making deliveries. He introduced Eliza to his brother Thomas. They married in 1895. For a few years, Thomas Brogan worked at Cousins and Hall. Then, he opened a confectionery and cigar shop at 110 Main Street. (Courtesy of the Bentley Historical Library.)

Printing Dynasty

Daniel and Thomas Edwards founded a successful publishing house, and it all began when they tried to earn some money while they were law students at U-M by mimeographing and selling class notes. Since their products were so popular, their business became so time consuming that they had to alternate years as students. By 1899, the brothers received their degrees. They put practicing law on hold while they established Edwards Brothers; however, not too long after, since they wanted to practice law, they turned the company over to their brother John J. Pictured are Daniel, Thomas, and John J. Edwards. Under John J.'s leadership, Edwards Brothers steadily grew, and it was John J.'s son John William (J.W.) whose "aggressive leadership" in the post–World War II era led the company to greatness. Edwards Brothers published a 167-volume Library of Congress catalog. In 1949, this family-owned company established a profit-sharing program for its employees, but it was not until 1950 that they hired their first full-time salesperson. The next year, J.W. became chairman of the board of directors passing the CEO baton to his son Joe. In 1954, J.W.'s other son, Marty, joined the company. By 1979, Joe had taken his father's place as chairman of the board of directors while Marty became president. At that time, Edwards Brothers employed 1,200 people and had sales of $60 million. Today, Edwards Brothers-Malloy continues the tradition. (Courtesy of the Bentley Historical Library.)

At the Corner of Olivia and Israel Streets

Ask anyone in Ann Arbor where the Burns Park area is, and the right answer will be given. This neighborhood south of Hill Street and west of Washtenaw Avenue remains a highly coveted place to live. Few, however, know that it was developed by a woman, Olivia Bigalow Hall. She and her husband lived on Washtenaw Avenue, so she knew the area well. After her husband died, Olivia began her real estate development plan. She offered her first subdivision in 1891, with the second following five years later. In doing so, she established a new standard because she insisted all the homes be set back from the street. Homes built earlier in the century were placed close to the street. By allowing for a large front yard, Olivia gave her neighborhood an elegant appearance. Like many developers, she named one street for herself and one for her late husband. Israel Street, however, was changed after World War II to Cambridge, but Olivia Street is still there to remind everyone of Olivia Hall. (Courtesy of the Bentley Historical Library.)

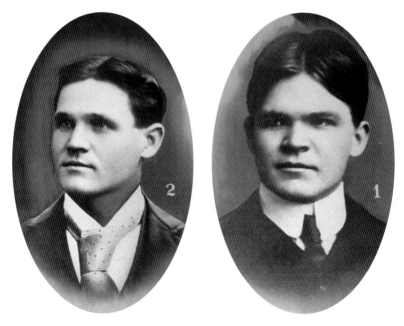

Gauging Success

In the 1970s, King-Seeley Corporation of Ann Arbor was sold to Chrysler for $28 million. Like Pfizer's sudden withdrawal decades later, the loss of King-Seeley, which employed over 2,000 people, created shockwaves throughout the city. What people today do not know is that this successful company began as discussions between two neighbors, Horace King (left) and Hal Seeley (right). King taught hydraulics at the University of Michigan. He had devised a system to determine water depth below Argo Dam. Seeley manufactured automobile windshields. When these two men got together, they recognized a mutual opportunity. In 1919, they established the King-Seeley Company and began making the first dashboard gas, heat, and oil indicators. Like so many start-up companies, King-Seeley began in Horace King's garage. It took four years before they sold their first gauge, but by 1925, they moved to a large building. By 1960, they had almost 50 million in sales. And then they were gone, leaving their factory to suffer neglect until it was renovated as Liberty Lofts condominiums.

Big Jim

People called James M. Ashley "Big Jim." He was big in physical size, big in his dreams and big in his accomplishments. He hailed from Toledo, Ohio, and served five terms as a congressman from that state. Few today know of his critical part in designing both the Thirteenth Amendment Bill and the Reconstruction Bill. After serving as the governor of Montana, he came to Ann Arbor where he lived at the corner of Main and William Streets. Ashley's impact on Ann Arbor can be found around the corner on the street named for him. Just south of William Street is a very modest building that once served as a train station for Big Jim's Toledo & Ann Arbor Railroad. The trains rumbled down those tracks taking families to Whitmore Lake on hot summer afternoons. They brought fans to Ann Arbor for football games; however, their primary purpose was to ship freight not just to Northern Michigan but across Lake Michigan to Elberta, Wisconsin. To accomplish that, Ashley utilized specially designed ferries that could be loaded with entire rail cars. Until 1969, the "Annie's" 292 miles of track was the longest line without a branch. Today, the depot building is a preschool, which has its own train car in the playground. (Courtesy of the Bentley Historical Library.)

Friendly Yugoslav

In the 1960s, the place for pizza was Bimbo's on East Washington Street. Unlike his more upscale restaurant, Café Dubrovnik on Washtenaw Avenue, the downtown restaurant had a grungy 1930s ambiance with peanuts in baskets. Patrons could eat the peanuts and throw the shells on the floor. Sometimes there would be a jazz band. There also was Pong, an early computer game. And of course, there was Bimbo. His real name was Matt Chutich. He liked to call himself the "friendly Yugoslav," but he was born in Minnesota. (Courtesy of the Peter Yates Collection, Bentley Historical Library.)

Patriarch

His parents wanted him to be a rabbi, but Osias Zwerdling, born in 1879 in what is now the Ukraine, apprenticed to become a tailor. As a young man, he immigrated first to Paris, France, and then to the United States. While working in Buffalo, New York, he decided to come to Ann Arbor. At first, Zwerdling worked at Mack and Company as the tailor and furrier, but in 1907, he opened his own store on Main Street. Eight years later, he moved the store to East Liberty Street. By 1926, he was selling only furs. The City of Ann Arbor designated his wall mural on Liberty Street as historic property, which means the painting of a wolf howling at the moon will be preserved for future generations. Zwerdling became a US citizen in 1911. He married and had three children. It was Zwerdling, with five others, who formed the Beth Israel Congregation. Recognizing the large number of Jewish students at the University of Michigan, he helped found Hillel, which is one of the largest in the country. Zwerdling retired in 1943 when he sold his store to Jacobson's. He continued as president of Beth Israel as well as being active with the Boy Scouts, YMCA, and Community Chest. Zwerdling was 96 when he died in 1977. (Courtesy of Beth Israel Synagogue.)

Sharing Success

The building at 1327 Jones Street was originally a brewery that used the natural spring water found there to make beer and the creek to cool it. The building had a brief life as an ice company and another as a creamery. For several years, it stood empty and forlorn. Then in 1920, it became the first cooperative foundry in Michigan—and perhaps the first in the United States. Production Foundry on Main Street had closed, leaving 10 men unemployed, so they solved their problem by starting the cooperative. Every member had to be an active worker. They did not allow investors. As the years went by, the number of members shrunk to two: Charlie Baker and Tom Cook. Baker was an African American whose ancestors had fled to Canada, where he was born in Buxton, Ontario, in 1886. Tom Cook, in contrast, was a Jewish refugee from the Ukraine. He had been arrested there for disseminating protest literature. His name was not Tom Cook; that was just the name they gave him at Ellis Island. Both had come to the United States and to Ann Arbor seeking opportunities for a better life. And they found it. For 52 years, their foundry employed up to 40 workers and remained in business by taking smaller orders that bigger companies refused. With their profits, they supported the Paul Laurence Dunbar Center for African American Youth and the United Jewish Appeal. Baker also helped found the Wild Goose Country Club, a pastoral retreat for African Americans. (Courtesy of the Bentley Historical Library.)

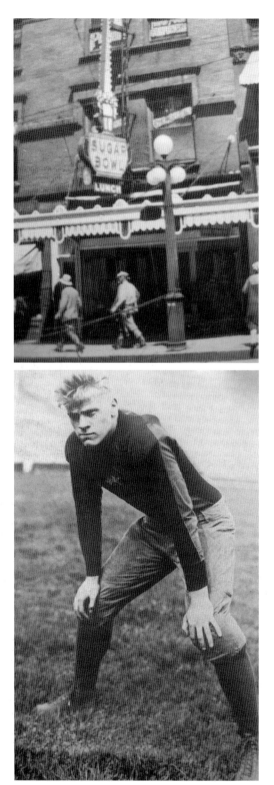

The Brothers Four

A foursome of Greek brothers left a lasting mark on local restaurant history. Immigrants Charles and Paul Preketes, who arrived in Ann Arbor in 1904, opened the Sugar Bowl on Main Street in 1911. The penny candy and ice cream operation grew to serving soups and sandwiches. The ice cream was hand-cranked in the building's basement, and hand-dipped chocolates were created in the upstairs living quarters. The duo saved on wages by bringing their 15-year-old brother Frank from Greece and then conscripted their youngest brother, 10-year-old Tony, to crank the ice cream. Tony was ashamed to go to school because his hands were so chapped from working with the ice and salt. But there was no slacking in education; his older brothers made sure he finished high school and three years at the University of Michigan before he was needed full time at the restaurant. By then, the business had expanded into two storefronts with marble counters and mirrored booths. This establishment sported the first neon sign on Main Street. In better times, the brothers reached outside the family for employees. One of those, a dishwasher, was a young football player for the University of Michigan by the name of Gerry Ford (pictured below). The future president of the United States earned 25¢ an hour. The Sugar Bowl closed in 1967, leaving a legacy of Greek-run restaurants in Ann Arbor. (Both, courtesy of the Bentley Historical Library.)

A Jewel of a Store

Main Street businesses come and go, but not Schlanderer and Sons. It is in its fourth generation as a locally owned and operated business, which makes it the oldest business on Main Street today. It was not always Schlanderer and Sons, nor was it always on Main Street. C. Henry "Hank" Schlanderer's father died when Hank was just a year old. At age 16, Hank began an apprenticeship with George Haller, a watchmaker. After Haller died in 1911, Hank and fellow watchmaker Fred Seyfried became partners, first on Liberty Street and then, in 1922, on Main Street. 20 years later, because each wanted his sons to be part of the business, they decided to split. Fred remained in the current building, while Hank moved a block north and opened Schlanderer and Sons. The Schlanderer sons were Paul and Arthur. Both graduated from the University of Michigan. Arthur was captain of the U-M hockey team. He also qualified for the Olympic team in 1932. Arthur then worked as a silver buyer for Hudson's in Detroit. Paul went on for his master's in accounting. Paul was busy not only with the store but also with serving on several real estate boards, as director of the Ann Arbor Chamber of Commerce, and as head of the University of Michigan Club. His death in 1949 at age 44 left Arthur operating the store alone until Paul's older son, Charles, joined him eight years later. Today, Charles's son Chuck Schlanderer continues the family tradition of quality and service. (Courtesy of the Bentley Historical Library.)

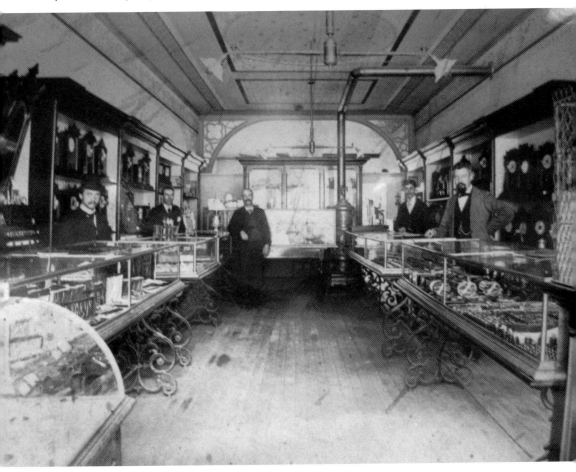

Meatballs on Madison

Dominick's restaurant has been an Ann Arbor hangout since 1959. Situated on Madison Street just south of the Law Quad, it quickly became the place to be. Legend has it that the idea for the Ann Arbor Film Festival began at Dominick's, and it witnessed its share of discussions between early Students for a Democratic Society members. But there was a lot more to Dominick DeVarti than his pizza sauce and meatballs. DeVarti was born in 1923 in Connecticut. His mother, who came from a small village in Southern Italy, taught him to cook. He served as a lieutenant in the Army Air Corps during World War II. He was a bombardier and navigator. After the war, he used the GI Bill to study engineering at the University of Michigan. DeVarti graduated in 1951 and began working for Kaiser Industries in Ypsilanti, Michigan. Six years later, he made a run for mayor of Ann Arbor but lost to William Brown, another war veteran and University of Michigan graduate. Two years after that, DeVarti opened Dominick's. He also owned a pizzeria in Ypsilanti. In the autumn of 1960, he sold that business to Jim, a young man who worked for him, because, he said, Jim was a "nice kid." Dominick demanded only one thing from Jim. He wanted him to change the pizzeria's name so everyone knew Dominick no longer owned it. Jim agreed. In less than a year, however, Jim traded the restaurant for his brother's VW beetle. His brother was none other than Tom Monaghan, and Domino's Pizza was born. (Courtesy of the DeVarti family.)

Kooky to Cultured

In 2014, two local stores closed, Middle Earth and the Selo-Shevel Gallery. Each closure left a gaping hole in the Ann Arbor shopping scene, but they could not have been more different. Cynthia Shevel, owner of Middle Earth, hails from California. San Francisco in the 1960s was the mecca of the antiestablishment culture, and Ann Arbor was changing rapidly. So, in 1967, Shevel decided to give up her quest for a doctorate and go into business. Middle Earth handled all sorts of funky things. It was a joy just to browse, and she recalls a time when customers had to line up just to get in. The Selo-Shevel Gallery was a totally different type of store. Elaine Selo (right) met Cynthia Shevel (left) 50 years ago at the University of Michigan. There are not many people in Ann Arbor who know that Selo has a doctorate in sociology. But she also has a great head for business. These women traveled all over the world enjoying other cultures and buying treasures for their gallery on the corner of Main and Liberty Streets. But all good things must come to an end. By 2014, it was time to say goodbye to two wonderful businesses and two amazing women who now live in California. (Courtesy of Elaine Selo and Cynthia Shevel.)

Main Street Sensei

Every day, people of all ages walk Main Street in their loose white uniforms and colored belts. They are either going to or coming from Keith Hafner's Karate School. Hafner, a graduate of Eastern Michigan University, purchased the school from his own karate instructor or sensei, Edward Sell, in 1979. Hafner's Karate School is not only one of the oldest businesses on Main Street, it is one of the largest karate schools in the United States. Hafner was born and raised in Dexter, Michigan. He first attended Michigan State University but transferred to Eastern Michigan University to become a teacher. Recently, he has become a Grand Master of Tae Kwon Do. Hafner believes karate training is more than just exercise or self-defense. For him, it is a way to build self-esteem and character. One cannot be a great teacher without enthusiastically embracing and living one's beliefs. Hafner has done that. In addition to his teaching, he is a dynamic speaker and generous donor to local causes, such as Food Gatherers and the Education Project for Homeless Youth. He produces a biweekly newsletter for his students and has written a book for parents called *How to Build Rock Solid Kids*. Much of the advice he offers comes from his own experiences raising his sons, Ian and Jason, who have joined their father working at the Karate School. (Courtesy of Keith Hafner.)

Colorful Curmudgeon

Behind a counter under hanging lightbulbs and stacks of newspapers sat Ann Arbor's legendary curmudgeon, Ray Collins. From 1927 until his death 51 years later, he kept watch over his Blue Front Cigar Store. Piles of newspapers from around the world, comics, paperback books, and magazines led to a citation by the City of Ann Arbor for maintaining a fire hazard. Collins paid the $20 fine and made some efforts to correct the situation. The Blue Front was probably the first place in town where the *New York Times* was available. A bundle of the *Times* was dropped off early on Sunday mornings, and eager readers pried the papers from the bundles, leaving payment on top. The store, which still sits at the corner of Packard and State Streets, was built in 1910 as the Fischer and Finnell Store. In the 1920s, it was called "the delta" due to its triangular shape. Later, it became known to the neighborhood as simply "the corner store." It carried penny candy, pulp fiction, and toys. Kids arrived with empty pop bottles so they could use the returned deposit to select candy, a comic, or a toy. Many a neighborhood youngster purchased his first "girlie" magazine there. Collins declared *Playboy* the biggest seller of his inventory that included magazines from Germany, France, Russia, and China. The *Daily Racing Form* was also available. Sometime in the 1950s, Collins decided not to entice children with toys. He hauled what he had on hand to the basement. When the store changed hands after Collins passed away, collectors purchased Barbies, Disney products, and Beanie & Cecil at the original grease pencil prices. (Photograph by Susan L. Nenadic.)

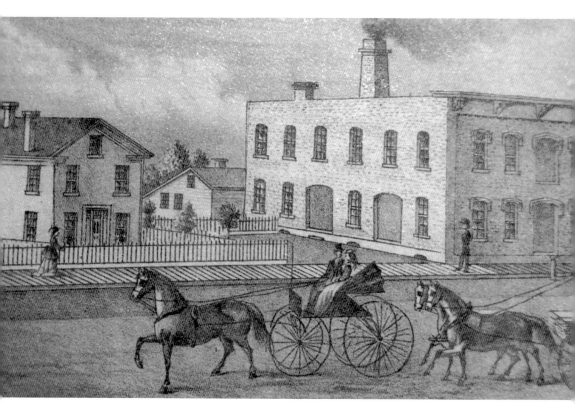

Cashing In

Long before Kerrytown, long before Zingermans, and just a year after Mayor Creal stopped the destruction of the North Central neighborhood, Demaris Cash had an idea that lived up to her name—Cash. She realized that there were no consignment stores in Ann Arbor, so she began looking for a building that was big enough and one that she could afford. Herman Krapf's planing mill, which had made sashes and doors, was standing empty on Detroit Street. For $200 a month, she leased the building and began what is now an iconic part of the Ann Arbor scene, the Treasure Mart. By 1983, she was able to buy the house and the mill. Demaris's daughter, Elaine, was only nine when her mother began the Treasure Mart. Today, Elaine operates the store with her husband, Carl Johns. They actually met at the Treasure Mart where both worked in the summers.

From Dairy . . .

In 1934, when it was first established, the Washtenaw Dairy was a true dairy, one of seven in Ann Arbor. Edwin J. Laubengayer and his wife, Mae, purchased the building from the Drugcraft Company. Their son, Don, and his friend Jim Smith were their first employees. The boys were at work by 2:30 a.m. to bottle and deliver the milk. Soon after Jim began working at the dairy, the Laubengayers hired Doug Raab to scoop ice cream. At that time, the Laubengayers made their own ice cream; although it comprised only a fraction of their business. By 1965, Don Laubengayer became the dairy's manager because his father had retired. Don and the Washtenaw Dairy led the way for other dairies by switching from glass bottles to plastic. (Courtesy of Jim Smith Jr.)

. . . To Donuts

Doug Raab and Jim Smith Sr. (left) bought the business from the Laubengayers in 1973. For many years, Doug managed the dairy. Eventually, Jim's son Jim Smith Jr. (right) took over. While keeping the name, they shifted the focus to ice cream, which they buy wholesale, and donuts, which they make themselves. It is hard to say which product is more popular. The line of kids and their families wanting to buy a cone or a shake reaches around the corner, and the donuts are considered the best in town, but what has really made the Washtenaw Dairy an iconic place in Ann Arbor has been the people. In a world of "upscale" and "deluxe," the Washtenaw Dairy remains a bit of a past. Nothing fancy . . . just good food at a reasonable prices and a comfortable place to congregate with friends. Go any morning, and you will find customers drinking coffee, eating donuts, and discussing the latest news. Doug, who just turned 90, will be one of them; sadly, Jim will not. Jim passed away in early 2016. (Courtesy of Jim Smith Jr.)

Ikebana Master

When Tom Thompson was growing up in Cadillac, Michigan, his piano teacher brought him to Ann Arbor for a concert by Vladimir Horowitz. Little did she know how that visit would determine the rest of his life. Thompson fell in love with Ann Arbor. So when all his fellow 1955 high school graduates headed to other schools, Tom came to the University of Michigan. He took a part time job at Louise's Flowers and Gifts on State Street to help pay his school expenses. Armed with a diploma in biology with emphasis on botany, Tom became the first lay teacher at St. Thomas High School, where all the other teachers were nuns. For the 1963–1964 school year, Thompson (dark kimono, center front to the right of his teacher) taught in Misawa, Japan, where there was at a US Air Force base. In his spare time, he began taking ikebana lessons. At that time, few Caucasians studied the art of Japanese flower arrangement. Returning home, Thompson resumed his teaching at St. Thomas while also working full time at Louise's Flowers. It did not take long, however, for him to open his own flower shop, the Petal Shop, which was located at first on Church Street near South University Street. Somehow Thompson managed to balance his teaching demands with his entrepreneurial efforts. He owes a great deal of his success as a florist to his sojourn in Japan and the ikebana lessons he took. His arrangements were quite different than the ones most Americans had seen. He designed asymmetrical combinations made from unusual flora. And he still does at Tom Thompson Flowers on Main Street. (Courtesy of Tom Thompson.)

CHAPTER EIGHT

Creative Ann Arbor

Some people are blessed with creativity. Creators are risk-takers. They have to be or they would feel too threatened to proceed with their ideas. Creators are imaginative thinkers. They need to be able to see something that does not yet exist. To do so, they expose themselves to a wide variety of stimuli. They do not feel threatened by different ideas or different people. They embrace that difference.

This creative gift takes many forms. It can be verbal, which is what inspires writers and poets such as Robert Hayden or Nancy Willard. It can be spatial, which translates into drawing, graphics, and designing. Katie Rogers and her uncle Randolph Rogers fit in this category, as do Bill Lewis, David Zinn, and Bill Shurtliff. It might be an intuitive feel for movement or music, which dancers like Peter Sparling and musicians such as William Bolcom or Mark Braun experience. Frequently, several areas of giftedness combine. Herb David and Gregg Alf need both musical and spatial talents to build their instruments. Creativity also can manifest itself in people who make an idea come to life. One may not know the Seglins or Cynthia Yao by name, but every Ann Arborite has heard of the Ark and the Hands-on Museum. And though many people perceive science as just academic training and experimentation, scientists such as Jonas Salk and Shirley Schwartz needed openness to ideas as well as creative imagination to find new solutions to practical problems. Whatever the gift, a creator must take that gift and do something. He or she must bring into existence something new, be it an idea or object.

Bands and Battles

Many Ann Arborites know about Otto's Band, but few would recognize C. Jacob Gwinner's name. Like so many in Ann Arbor, Gwinner was of German descent. His father, Gottlieb Friedrich Gwinner, was a butcher, but C.J. found no allure in that profession. He became a musician. He and his two brothers enlisted in the Union army in 1861 and joined the band. His brothers quit when their one-year commitment ended, but C.J. stayed two years as military bandleader. In 1868, having returned to Ann Arbor, he established the Porter-Zouave Band, which played throughout Lower Michigan. Zouave soldiers were a light-infantry group, which marched in double time and did not utilize close-order drill; however, they are better known for their loose gathered pants and fezes. Zouave companies derived from North African models. The origin of the word "Porter" remains a mystery, though it may refer to General Porter in the Civil War.

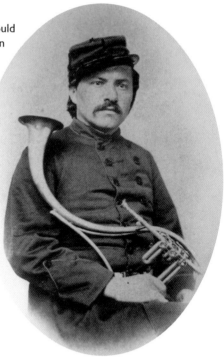

Sisters?

Cheryl, Connie, and Grace are not related, but they are close in harmony. They are the Chenille Sisters, who have been entertaining crowds in Ann Arbor for 30 years. The Chenille Sisters write their own lyrics, and their songs range from gentle ballads and soulful offerings to outrageously humorous songs. Yet the trio's contrasting personalities meld into harmonious entertainment. Besides her vocal skills, Connie Huber (center) adds drums, guitar, and piano to the mix. Cheryl Dawdy's (left) soprano voice blends with the instruments and the more intriguing antics of Grace Morand (right). Having started their careers as sisters at Ann Arbor's Old Town Tavern, it did not take long for them to attract the attention of Garrison Keiler of radio's *A Prairie Home Companion*. After many years on the road full-time, the sisters now stick a little closer to home yet still do a couple of concerts each month. And their fans clamor for more. (Courtesy of the Peter Yates Collection, Bentley Historical Library.)

Twins

Gemini, a nationally known music group, compose and play music reminiscent of the heyday of folk music in the 1960s. Their music takes an older audience on a trip down memory lane with visits to Pete Seeger; Peter, Paul and Mary; and Simon and Garfunkel, to mention just a few. Younger audiences love them, too. Their music invites the audience members to clap their hands, stamp their feet and sing along. Gemini's repertoire includes Irish and Scottish folk music, Hispanic tunes and pop, in addition to Hungarian, Yiddish, and Israeli music, which come from their own cultural heritage. Though they specialize in guitar, violin, and mandolin, if an instrument has strings they can play it. Why call themselves Gemini? The astrological sign, Gemini, is the twins. The name is perfect because Sandor and Laszlo Slomovits are twin brothers, which may be why their voices blend so well. (Courtesy of Gemini.)

Boogie-Woogie on Wheels

Anyone who has gone to the Ann Arbor Art Fair or is a fan of boogie-woogie knows Mr. B. He has played at every art fair since 1982. Born in Flint, Michigan, Mark Braun spent his high school years playing football and performing with a band he organized. They called it the Schnozz Brothers since all the members had formidable noses. In 1974, when he was 17, he drove to Ann Arbor to hear Boogie-Woogie Red at the Blind Pig. Totally enthralled, he spent many evenings listening and staying late to play with Red. When he was a freshman at the University of Michigan's School of Music, Steve Nardella asked him to join his band. The Nardella Band was one of the most popular groups Ann Arbor has ever seen. Mark Braun never did graduate. He eventually left the band, made his own record, and went to Europe. Today, he is world famous and can be seen on his bike towing his piano. (Courtesy of Mark Braun.)

Starting Early with No End in Sight

At two, he picked out tunes on the piano; at six, he read Shakespeare and took piano lessons; and at twelve, he composed a string quartet. Who is this modern Mozart? He is William Bolcom. After studying at the University of Michigan and in Paris, Bolcom returned to U-M to become chairman of its Composition Department in the School of Music. In 1988, he won a Pulitzer Prize for his composition "Twelve New Etudes for Piano." The list of his accomplishments goes on and on: Grammy Awards, scores for Broadway musicals, opera, a 2006 National Medal of Arts and in 2007 Musical America's Composer of the Year. Chicago's Lyric Opera commissioned two operas, composed in collaboration with librettist Arnold Weinstein and writer Arthur Miller. Bolcom also has composed for artists such as James Galway and constructed a concerto for the left hand for two pianists with disabilities. After 25 years of working on a piece inspired by William Blake's "Songs of Innocence and of Experience," Bolcom saw its premiere at the Stuttgart Opera with performances across the United States and England. He appears and records with his wife, mezzo-soprano Joan Morris. Bill Bolcom's unusual music draws from many traditions: opera, bluegrass, soul, folk, reggae, rock, ragtime, vaudeville and symphony. Once, just for the fun of it, Bolcom composed a ditty, "Green Jell-O, Marshmallow, Cottage Cheese Surprise," to capture the food he was offered in his early days playing piano for ladies' luncheons. (Courtesy of William Bolcom.)

A Man of Many Talents

What little manufacturing Ann Arbor has had in its history has pretty much disappeared. In its place, artisans, particularly musical instrument craftsmen, have established themselves. Herb David, marathon runner and prize-winning gymnast, abandoned his career as a psychologist and reinvented himself as a maker of stringed instruments. He played trumpet in high school and in a military band during the Korean War. For a while, he was first chair in the Louisville Philharmonic playing French horn. He did not begin learning guitar until after the war. He credits his teacher Sam Varjabedian, a maker of ouds and lutes in Detroit, for helping him transition to his second career. At first, David worked out of his home, then in a studio on State Street, and finally, came to rest in the house on the southeast corner of Liberty and Fifth Avenue. Hundreds of people could walk by that house every day, never guessing that it was much more than just a place that taught guitar. Herb David is world famous. He has repaired guitars for performers such as Eric Clapton and John Lennon. When the Stearns Collection at the University of Michigan or the Smithsonian needed restoration for instruments in their collections, they contacted Herb David. If it were made of wood and had strings, he could make it. Before he retired, he made about a dozen instruments a year: dulcimers, lutes, banjos, balalaikas, and guitars. (Courtesy of Herb David.)

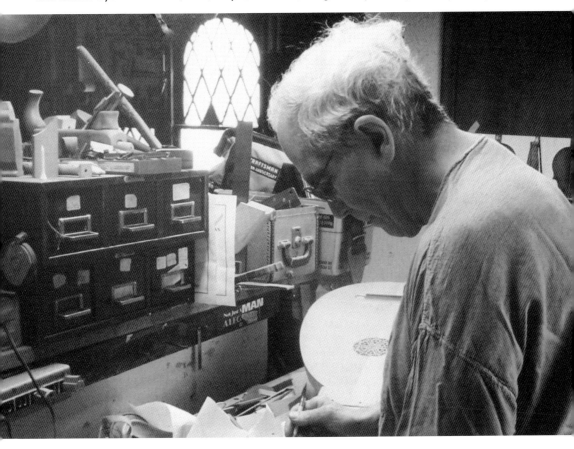

Arbor Stradivari

Herb David is not the only instrument craftsman in Ann Arbor. Gregg T. Alf (foreground) met Joe Curtin (background) in Cremona, Italy. Alf was born in Los Angeles in 1957; Curtin in Toronto. Each wanted to learn how to make the finest instruments possible, so they went to Cremona, which is where Stradivari set the standard for violin making. When they decided to return to the United States, they visited Chicago first and then Detroit. Perhaps an order from University of Michigan's Ruggiero Ricci helped them choose Ann Arbor as the site for their studio. Ricci's violin sold in 2013 for $132,000. They both make a dozen instruments a year, but they now have separate workshops. Whenever Alf is not in Italy, he can be found right here in his Ann Arbor studio. (Courtesy of the Peter Yates Collection, Bentley Historical Library.)

Physics, Geology, and Math—Oh My!

More than just a local attraction, the Ann Arbor Hands-On Museum each year entertains hundreds of thousands of visitors of all ages from various states and countries. Established in 1978 by Cynthia C. Yao, with approval from Ann Arbor City Council, the museum found its permanent home in Ann Arbor's historic brick firehouse. The museum has interactive outreach programs that take its show on the road or broadcasts it through video conferencing. For 22 years, Yao led the museum as its executive director, furthering her "hands-on" philosophy as a key to learning and teaching. She was inducted into the Michigan Women's Hall of Fame for her roles in education and science. (Photograph by M. Joanne Nesbit.)

No Animals Allowed in This Ark

Those who wait patiently on the sidewalk in all sorts of weather to enter The Ark for one of its 300+ performances each year might be surprised to learn that the Ark was originally established as part of a Christian ministry. In 1965, four Ann Arbor churches joined forces to create a coffeehouse and folk singing venue on Hill Street owned by First Presbyterian Church. It offered Sunday night religious services and weekday discussion groups as well as music. So the name refers to Noah's Ark, a place of refuge in the crazy days of the late 1960s. It was Dave Seglin and his wife, Linda, who, depending on your perspective, made or ruined the Ark. Seglin majored in music at the University of Michigan. He received his master's at Eastern Michigan University, which is where he met Linda. For a while, he taught guitar at Herb David's studio. The Seglins moved into the house on Hill Street when Dave became the resident manager for the Ark. Their first show was standing room only, which resulted in the building inspector demanding expensive changes to the house. Despite its obvious popularity, the churches stopped funding the project in 1973 since they felt it had moved away from their original intention. Seglin by then was hooked on the idea. In 1977, he and Sue Young planned the first Ann Arbor Folk Festival to raise money. Other supporters helped with fundraising to keep the Ark alive, first on South Main Street near Madison Street and, later, in its current home downtown. (Courtesy of the Peter Yates Collection, Bentley Historical Library.)

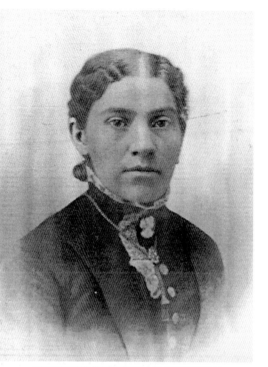

Art in the Family

Artistic talent ran in the Rogers family. Its most famous member was Randolph Rogers, who had an international reputation as a sculptor. He created the bronze doors for the Capitol Building in Washington, DC. The "Nadia" at the University of Michigan's Museum of Art is the most locally famous of his works. Randolph came to Ann Arbor from New York with his parents and his brother Moses. The brothers attended local schools, but then their paths diverged. Randolph moved east while Moses stayed in Ann Arbor, eventually owning a farm implement store. Moses's daughter Katie, after graduating from Ann Arbor High School, went to Chicago to attend the Chicago Academy of Design. There, she graduated first in her class. Then, she returned to Ann Arbor where she painted many portraits, including the one of Judge Kingsley found in Chapter Five. Her art career was put on hold, however, when her father died in 1888 and she managed his business. For the final seven years of her life, she returned to her passion: art.

Mural, Mural on the Wall

Tree town is rapidly becoming "mural town." The newest are a depiction of *Singing in the Rain* on the Fifth Avenue parking entrance south wall and two murals at 208–210 South Fifth Avenue done by Cathy Gendron and her students from the College for Creative Studies in Detroit. Measuring 125 feet and four stories, Gendron's will certainly be the largest. The oldest mural, which depicts a wolf howling at a full moon, is just around the corner on Liberty Street. It advertised the Zwerdling Fur Shop, established in 1904. The most iconic wall mural, however, is farther east on Liberty Street at State Street. In 1984, Richard Wolk, a University of Michigan student, asked David's Books if he could paint a book-related mural on the building's outside wall. The owners agreed. Ever since then, authors Woody Allen, Edgar Alan Poe, Hermann Hess, Franz Kafka, and Anaïs Nin have been watching over that busy intersection. Wolk no longer lives in Ann Arbor, but he returned in 2010 to refurbish his 20-by-6-foot masterpiece. (Photograph by Susan L. Nenadic.)

Still a Happy Kid at Heart

A *Mad* magazine enthusiast, copying many of the cartoons and line drawings he saw there, this Ann Arbor youngster found a value in and love for art while in junior high school and has never slowed down. Bill Shurtliff enjoyed a small following for his own cartoons while serving in the US Army in the late 1960s and followed that three years of service by entering the University of Michigan School of Art, graduating in 1976. But Shurtliff discovered that there were no job recruiters anxious for someone with a degree in fine art. By that time, the happy kid was grown up with a family to support, but finally, he found recognition for his pen-and-ink drawings of local scenes through a gallery display. "I not only got a lot of positive feedback," he said, "but I sold a few. That marked the beginning of my professional career as an artist." With those hard times behind him, Shurtliff continued working, creating hundreds of pen-and-ink drawings, oil paintings, and sculptures. His illustrations have appeared in books, art publications and commissioned drawings of homes and businesses. He has established his own business, producing cards and calendars, and continues to display his works in shows and galleries. These paintings and drawings of Ann Arbor, the surrounding area, and the U-M campus are treasured by those who live in Southeast Michigan as well as those who are just passing through. "Looking back," Shurtliff said, "I am very grateful for my love of art and any gifts that I've been given. Even now, sometimes when I'm painting or drawing, I feel like a happy kid!" (Courtesy of Bill Shurtlif.)

No Strikes. No Outs. Just Hits!

Once this New York native found Ann Arbor, he just stayed. As a University of Michigan student, Alfred Slote won the coveted Hopwood Award for his writing. After graduation, he wrote and produced educational television programs for the University of Michigan. When he was done for the day with that job, he coached baseball and played squash. Baseball was imbedded in Slote, who became a successful children's author known primarily for his sports and science fiction novels. His 1991 book *Finding Buck McHenry* was adapted into a 2000 television film. Another of his baseball books, *Jake*, became the subject of a short documentary on the man and his writing. This 1971 tale of Jake follows a young African American ballplayer in a Michigan town called Arborville. The author's young fans were known to haunt bookstores across the country waiting for the next publication. One fan remembers riding his bike to Slote's house where the two of them talked about Jake, and the author signed his paperback edition. (Courtesy of the Peter Yates Collection, Bentley Historical Library.)

Got Chalk?

David Zinn does. As a chalk artist, Zinn has been astounding Ann Arbor with what has been called "pointless" art since 1987. His three-dimensional work often appears as a mouse climbing out of a curb or a green monster raking leaves on a sidewalk. In addition, he frequently draws a flying pig and a lot of mice on sidewalks, Manhattan subway platforms, and illustrations for books, T-shirts, posters, advertisements, and educational comics. But wait! One can even find these characters on bar coasters, restaurant placemats, cake icing, and even snow. Always using a precise viewpoint that will make his characters look real, Zinn sometimes uses a long bamboo stick with a piece of chalk or charcoal wedged into its end and sometimes a collapsible cane as used by the blind. A self-taught artist with a degree in creative writing and English language from the University of Michigan, Zinn has taught both creative writing and scene painting for theater sets and has performed in Gilbert & Sullivan operas. He records audiobooks and has starred in two children's radio shows: *The Rug Rat Revue* and *The Mud Pie Café*. Zinn also has designed costumes and sets for theater productions in New York City. (Courtesy of David Zinn.)

Dear Mom, Send My Paints

Called to active duty from the Naval Reserves, William "Bill" Lewis put his University of Michigan education on hold to serve on the USS *Marcasite* in San Diego. While officials frowned on photography in and around military bases, Lewis was allowed to draw and to produce watercolors. If he had been taking photographs of his various assignments, Lewis said that he probably would have been shot. "But nobody seemed to pay any attention to a painter working on board the boat." Across the Pacific, into Tokyo Bay and bombed-out Yokohama, Lewis continued documenting in paint the ships of the Pacific fleet and the sailors who manned them. He painted ships plying the routes of war, ships engaged in battle, and ships limping into drydocks for repairs. Once the war was over, Lewis returned to Ann Arbor and his studies, eventually joining the U-M School of Art faculty. But more than capturing World War II in watercolors and teaching at the university, he continued as a producing artist and supported local causes and organizations. Lewis was one of the founders of the Ann Arbor Potters Guild and supported the United Way and the Blood Donors Association. (Courtesy of Bill Lewis.)

Hollywood's Dynamic Duo

Hollywood's lure called two Ann Arborites. One was Shirley W. Smith, pictured, who served as the University of Michigan's secretary. He was in charge of keeping the university's business affairs in order and communicating with executive officers. It was Smith who guarded the university's official seal. He authored several books, but it was a short story that brought him to U-M graduate Valentine Davies. Davies was a film and television writer, producer, and director who had won an Academy Award for his Christmas classic *Miracle on 34th Street*. In the mid-1940s, the duo brought Smith's story *It Happens Every Spring* to the screen with its premiere at Ann Arbor's Michigan Theater. The whimsical story, written long before *Flubber*, features a chemistry professor who accidently finds a substance that will repel baseballs. With a leave of absence to pitch in the big leagues, the professor becomes a star, propelling his team to the World Series. Davies, who made the film deal, wanted the picture's locale to be Ann Arbor with the Detroit Tigers as the big league team, but complications negated the idea. (Courtesy of the Bentley Historical Library.)

One Very Smart Lady

Ellen Shirley Eckwall Schwartz was born in 1935 to a Swedish immigrant family. Shirley grew up in Pleasant Ridge, Michigan; graduated from Ferndale High School in 1953; and went to the University of Michigan to study foreign languages. In addition to Swedish, she is fluent in German, French, Spanish, Japanese, as well as English. Needless to say, Shirley was a very smart lady. Fortunately for automobile drivers, she changed her major to chemistry earning her doctorate in 1970. During her career, she has received several patents, like the oil gauge on cars, and has been inducted into the Michigan Women's Hall of Fame. While at the University of Michigan, Shirley was a championship diver. In fact, her husband, Ron, likes to joke that she "fell for him" when they were students. The truth of the tale is that he was spotting her while she practiced back flips on a trampoline. Shirley missed her landing and fell into his arms. Mrs. Schwartz died in May 2016. (Courtesy of Ron Schwartz.)

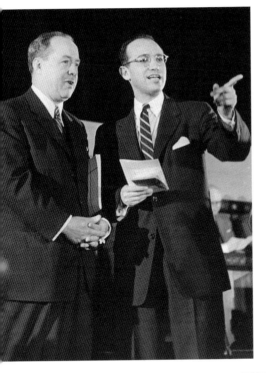

It Works!

Polio was the scourge of the early 20th century. Surveys from the 1950s indicate that people feared polio second only to nuclear war. People were desperate for a vaccine to prevent that dreaded disease. Jonas Salk rightfully has been credited with the discovery of just such a vaccine, but would he have done that without the training and assistance he received from Tom Francis? Tom Francis graduated from medical school at Yale and became the head of the University of Michigan School of Public Health's Department of Epidemiology in 1942. Salk worked in Francis's lab for six years before moving on to the University of Pittsburgh, where he became head of the virus research lab. It was there that he developed a vaccine for polio. Because of his history with Tom Francis, it was natural for Salk to return to the University of Michigan to have his vaccine tested. On April 12, 1955, Salk (right) and Francis (left) were ready to announce to the world that the vaccine worked. In honor of Tom Francis's contributions, the University of Michigan established one of its most prestigious honors, the Francis Medal. (Courtesy of the Bentley Historical Library.)

Doyen of Dance

Born in 1951, Peter Sparling, at age eight, begged his mother for dance lessons; however, he gave them up in less than a year in order to study violin. As a student at Interlochen, his future was not yet set in stone, but the choice to take dance as a physical education credit was a hint. Then, he left Michigan for the Juilliard School in New York. It was there that Peter Sparling realized that dancing was what he must do with his life. For a few years, he danced with the José Limón Dance Company, but it was Martha Graham, a temperamental doyenne of dance, who influenced him the most. He was her principal dancer and assistant for six years. Today, he teaches dance at the University of Michigan as well as the Peter Sparling Dance Company. Though he no longer dances, he says it gives him a real "high" to see his choreography performed. (Courtesy of the Bentley Historical Library.)

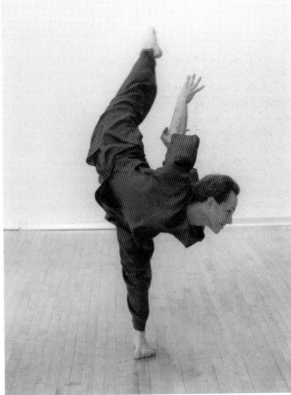

Potts and Pots

Known to Ann Arborites as a fighter for the city, Ethel "Eppie" Potts is still in the midst of battles. From the 1970s with the city's planning commission to promoting the Old West Side as a historic district, Potts has shared her vision and determination with her adopted city, its residents and officials alike. She came to Ann Arbor from the Chicago area to earn a degree in geology from the University of Michigan. Then, she discovered pots. From a chance encounter witnessing someone "throwing pots," she was hooked on clay. Potts was the Ann Arbor Pottery Guild's first nonmember student. Since then, she has organized, studied, and taught with the group. Over the years, the Ann Arbor Pottery Guild has expanded not only its physical home but its mission to include the public interested in working with clay. These artists submit their work around the country, garnering many awards and purchases by museums. So a would-be geologist and once a prizewinning oboist has morphed into an activist and clay artist. As Potts has said, "Everybody likes to play in dirt." (Photograph by M. Joanne Nesbit.)

There Was Room at the Inn

Her poems about a child's overnight stay at William Blake's Inn won the coveted Newbery Medal in 1982 for the "most distinguished contribution to American children's literature." Long before that, Ann Arbor native Nancy Willard won the University of Michigan's coveted Hopwood Award for writing while a student. Known today as a novelist, poet, author, and occasional illustrator of children's books, she has not moved far from her roots. She sets her novels, such as *Things Invisible to See*, in her hometown in the 1940s. Critics have noted that this work opens with two brothers becoming involved with a paralyzed young woman. The baseball game at the end predates the film *Field of Dreams* in its player lineup of baseball luminaries. Retired as a professor and lecturer at Vassar College, Willard has continued garnering national awards for her works including the Michigan Author Award in 1994. Willard has not only returned to Ann Arbor, but she has also donated her archive and the replica she built of her vision of William Blake's Inn to her alma mater. (Photograph by M. Joanne Nesbit.)

CHAPTER NINE

Emerging Legends

In literary terms, a legend is a story about a real person or event, but the story itself is not accurate. As it is told over and over again, it changes. Every American child hears the legend of Johnny Appleseed. Did Johnny Appleseed really live? Did he really walk barefoot around the Midwest planting apple trees? Did he wear a pan on his head instead of a hat? The answer, of course, is "not quite." There was a man named John Chapman. Chapman bought land and established orchards in Pennsylvania and Ohio. He would return years later and sell the land at a profit. When he died in 1845, he still owned 1,200 acres. George Washington is another legendary American. Hundreds of biographies have been written, yet legends about him remain and are retold over the years. One of the legends is that, as a boy, he chopped down a cherry tree. The moral of the story is that he could not tell a lie. Is it true? Sadly, no, yet the legend remains popular.

Time is the most important aspect of legends. It takes time for a real person to do something that makes him or her memorable. That is why many of the people in this book are from the past. They are gone, but their influence on the city remains. Some of the subjects in this book are still alive and readily recognized. This chapter, however, is taking the risk of suggesting a few, more recent Ann Arborites who might fill the pages of a book, like this, if it were published 50 years from now. And their "legendary" stories are all true.

His Own Neighborhood

Always a fan of *Mister Rogers' Neighborhood*, Ann Arbor native Davy Rothbart has explored his own neighborhood and more as an author, filmmaker, publisher, and contributor to NPR's *This American Life*. His magazine *Found*, based on discarded notes, letters, flyers, photographs, lists, and drawings that he finds or that are sent to him by readers, gives life to his and other neighborhoods. The magazine morphed into books that led to appearances with television talk-show hosts. Among all this attention, Rothbart founded an annual hiking trip for inner-city kids. Participants need only a pair of sneakers to spend a week camping, climbing mountains, and exploring wilderness areas. Rothbart has taught creative writing at Cotton Correctional Facility in Jackson, Michigan; coached basketball at Ann Arbor's Community High School; directs the *Found* magazine's Prison Pen-Pal Program, which connects Found readers on the outside with those behind bars; and is active with both local and national youth writing programs. This former Chicago Bulls ticket scalper tours to share finds, inviting others to share theirs as well. His musician brother, Peter, often accompanies him, and it was Peter, not Davy, who, at age six, wrote to Fred Rogers and began a correspondence that led the family to visit the TV legend in Massachusetts. "Mr. Rogers invited all of us to chill with him for a day at his summer home on Nantucket," Rothbart wrote for the *New York Times* on the occasion of Rogers's death. "We had a glorious time. Mr. Rogers sang songs to us, played with us in the sand and told us stories about our friends from the Neighborhood of Make-Believe. It was a day I have never stopped glowing about." (Courtesy of Davy Rothbart.)

Grandmother's Scones

Lisa McDonald was born and raised in Colorado. After graduating from the University of Colorado, she decided to backpack through Europe. That trip, which was supposed to take a few months, turned into a 14-year experience. She taught at the Deutsche American Institute and consulted for international businesses. Consulting resulted in worldwide travel, during which Lisa always would find the nearest tea shop in whatever city she happened to be in. At first, Ann Arbor was not on her radar; however, a series of events changed that. The first was when she taught United Nations Politics and Policies at the University of Tubingen, Ann Arbor's sister city. Also, many of her consulting clients were in the automobile industry, but it was not until Lisa met her future husband, Mark, that Ann Arbor started becoming part of her life. Mark was a University of Michigan graduate. It was in Ann Arbor during play groups with many international residents that Lisa realized the need for a good tea shop. She opened her Tea Haus, in December 2007, five days after her second son's birth. Three years later, she doubled the size of the shop and began serving little sandwiches, scones, and macaroons. Lisa's Tea Haus has become a vital part of the Kerrytown scene. She now experiences many return customers. One newcomer to Ann Arbor asked her advice concerning several computer dating profiles. Her input was so helpful that he not only had his engagement photographs taken at the Tea Haus but also had a pre-wedding party there and, later, a baby shower. (Courtesy of Lisa McDonald.)

Guilt or Innocence

David Moran, professor of criminal law and procedure, cofounded the Michigan Innocence Clinic in January 2009 with Prof. Bridget McCormack. He and his students at the University of Michigan School of Law were able to exonerate eight men and two women in the clinic's first six years. One of the fortunate 10 was Dwayne Provience (second from left), who is photographed here with Moran (center), McCormack (left), and two student attorneys Judd Grutman and Brett Degroff. Professor Moran has earned many degrees, including a bachelor's of science in physics from the University of Michigan; his master's of arts and certificate of advanced study in mathematics from Cambridge University; his master's of science in theoretical physics from Cornell University; and a juris doctorate from Michigan's School of Law. He has argued six cases before the US Supreme Court. Perhaps his most famous case, Halbert v. Michigan, foreshadowed his interest in establishing the Innocence Clinic. Halbert struck down a Michigan law that denied appellate counsel to indigent criminal defendants who wanted to challenge their sentences. Before joining the faculty at the University of Michigan, Moran taught and was associate dean at Wayne State University School of Law. McCormack is now a justice of the Michigan Supreme Court, but Moran continues to teach and guide the Innocence Clinic in Ann Arbor. (Courtesy of David Moran.)

Sound of Music

Deanna Relyea is one of so many in this book who came to Ann Arbor to attend the University of Michigan and never went home. She was born in Detroit and graduated from high school in Pontiac. In 1984, she was searching for a venue where she could give piano lessons. Meanwhile Carl Brauer, who had hoped to raze the mid-19th century house across from the Farmers' Market, realized he could not since it was protected as a historical building. So he began remodeling it, and Relyea rented it. From those humble beginnings, the Kerrytown Concert House was born. Deanna's background as a pianist as well as mezzo-soprano was perfect training for her new roles as executive and art director. She also knew the musicians in Ann Arbor. Her intent was not to compete with the University Musical Society but to provide an intimate setting for private concerts and recitals. Bill Bolcom and Joan Morris performed at the Concert House's grand opening in September 1984. Since then, Relyea's hard work has paid off. She has been able to purchase not only a Steinway grand piano but the building as well. Deanna has recently retired as executive director, but she continues using her talents as artistic director. (Courtesy of the Peter Yates Collection, Bentley Historical Library.)

Babo's Girl

Sava Lelcaj is living proof that, with hard work and vision, the American dream is still a reality. She was five years old when her family fled Albania. After a few months in a refugee camp, her family received sponsorship from relatives first in the Bronx and then Hamtramck, Michigan. Being part of a culture in which girls marry young, she knew that was not for her, so Sava went to Wayne State University. Her experience in the restaurant industry began when she was 13 and got a job bussing tables. Later, she lived in Toronto. It was there that Sava gained exposure to upscale restaurants. Returning to the Detroit area, she opened a greasy spoon café in Hazel Park. But as unemployment climbed around 2007, she realized it was time to move on. So she came to Ann Arbor, where she became a one-woman operation in a tiny eatery on State Street. Today, at age 32, her company, Savco Hospitality, includes three restaurants: Sava's, Babo (the Albanian word for father), and Aventura. She attributes her success to a sincere belief in old-school hospitality while also evolving to stay ahead of market trends. She believes a business, whether it is a greasy spoon in Hazel Park or Aventura, must be an outgrowth of the community. Savco Hospitality offices occupy the second floor of the building on the northeast corner of Fifth Avenue and Liberty Street, where her office windows overlook the intersection. On the inner wall, a large American flag symbolizes all the success she has found in the United States and in Ann Arbor. And by the way, she did marry in 2013. When asked where she met her husband, she said, "At the bar at Sava's." (Courtesy of Sava Lelcaj.)

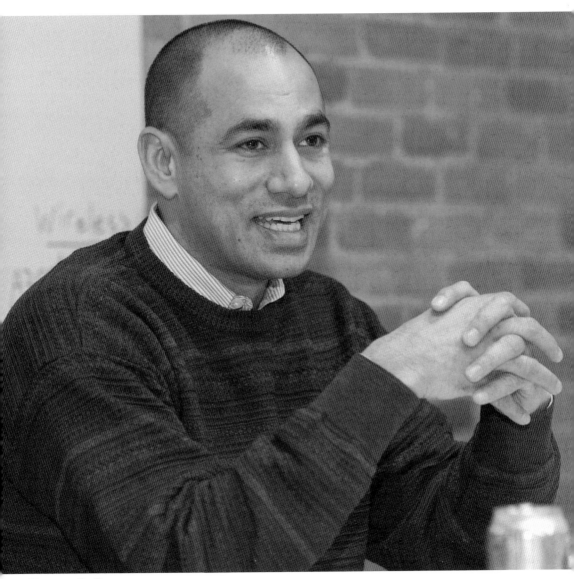

Nonprofit Guru

Neel Hajra personifies today's Ann Arbor in so many ways. His parents met there, and he was born there. He is the product of the Ann Arbor Public Schools and the University of Michigan, where he earned a bachelor's of science in physics and his juris doctorate. His Indian heritage reflects Ann Arbor's ethnic diversity. After graduating from the School of Law in 1998, he worked for three years as a corporate attorney for Ford. Dissatisfied with that role, he joined Ann Arbor's Nonprofit Enterprise at Work (NEW), where he became chief executive officer in 2008. That experience and a strong commitment to the future of nonprofits resulted in his being selected as chief executive officer of the Ann Arbor Area Community Foundation, a nonprofit supporting other nonprofits. He also teaches Policy and Management in the Nonprofit Sector at the Ford School of Public Policy at the University of Michigan. Much of Neel's success is due to his ability to recognize all the separate groups in the area while also seeing the big picture, which is so necessary for the future of Ann Arbor. (Courtesy of the Ann Arbor Area Community Foundation and Neel Hajra.)

Don't Trash Michigan

The old adage about how the good die young certainly was true in the case of Mary Beth Doyle (foreground), who died November 13, 2004. She was a 43-year-old wife and mother to three, but it was her work outside the home that marks her for distinction. In 1993, she began working at the Ecology Center on East Liberty Street. She brought to her work a profound wonder for the beauty of nature and a dedication to the principles of ecology. During her 12 years at the center, she helped ban mercury thermometers in Michigan as well as saving land in Washtenaw County as green space, to name just two of her many accomplishments. It was not just what she did but how she did it that made everyone smile. One of her campaigns was in response to the State of Michigan allowing non-Michigan residents to dump waste in "the mitten." For her "Don't Trash Michigan" campaign, she created new lyrics for the popular Elvis Presley song "Return to Sender," and it went as follows: "Return to sender / address unknown / Don't want your trash here / so keep it at home." To honor Doyle's memory, a Michigan bill banning dangerous flame retardants was named for her on January 1, 2005. Locally, the 81.4 acres bordering Mallett's Creek also was named for her. It is a fitting memorial, since the goal for the park is to reestablish a wetlands, which will improve water quality in the Huron River. (Courtesy of the Ecology Center.)

It's a Mystery

Its nearly 30,000 mysteries have been keeping local sleuths busy. With that inventory, Aunt Agatha's, a locally owned and operated mystery bookstore located in the heart of downtown, has been satisfying readers for nearly 25 years. One can find everything from the familiar preteen offerings to classic and contemporary mystery and crime stories. For proprietors Jamie and Robin Agnew, reading is just part of life, and the love of mysteries started early. Jamie, a transplant from Pittsburgh, Pennsylvania, began with the Hardy Boys, which he says was then considered trash literature. Robin, who was born on Michigan's Mackinaw Island, started out with Nancy Drew but, during middle school, became enamored with the challenges of Agatha Christie. The couple's

efforts have been rewarded with the 2014 Raven Award, presented by Mystery Writers of America, for their outstanding work in the mystery field without being authors. Robin has served on the Kerrytown BookFest Board as both a member and as president. The couple also reviews books for *Mystery Scene* magazine and other publications, issues a newsletter, and hosts authors and a monthly book club. In her little downtime, Robin creates collages with words cut from the pages of books. (Photograph by M. Joanne Nesbit.)

Setting the Table

Eating ice cream at her grandmother's enameled kitchen table is a fond memory. And so are the set of plastic dishes along with fake plastic food she received one Christmas. But suffering from chronic food issues relating to anorexia nervosa since the 1960s, Margaret Carney has dealt with these issues by buying and reading cookbooks and cooking for others. She even wrote a tongue-in-cheek anorexia nervosa cookbook in the 1970s that was soundly rejected by publishers. These challenges did not deter Carney's passion for food, dinnerware, and all related paraphernalia. Decades later, Carney is hoping to find a permanent home in Ann Arbor for her collection. The future museum's permanent collection will include around 4,000 objects. Those objects range from ancient to futuristic designs created from ceramic, glass, plastic, metal, lacquer, fiber, paper, wood, and more. She describes her museum-to-be as "a dream museum one place setting at a time." Carney holds various degrees in Asian art history, anthropology, and archaeology that allowed her to become a noted historian of ceramics. As a museum professional for more than three decades, she has curated exhibitions, presented public lectures, and authored books, catalogues, and journal articles. She periodically teaches ceramic world history at Ohio State University and recently completed the first book about lithophanes in the 180 years of their existence. (Courtesy of Margaret Carney.)

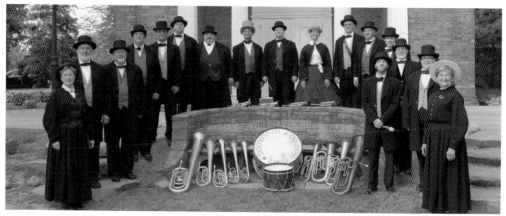

Oldies but Goodies

Alex Pollock was working in Detroit when he founded the Dodworth Saxhorn Band. It has now transferred its location to Ann Arbor. The band features 19th-century music and uses instruments and uniforms appropriate to that era. Alan Dodworth, for whom the band was named, redesigned saxhorns so that the bell faced backwards over the player's shoulder. The band debuted in 1985 at Greenfield Village, with Tim Hoover conducting and Michael Deren acting as the business manager. As its fame grew, they received offers to play at venues both within and outside Michigan. Like war reenactors, they pride themselves on authenticity. When the band provided the music for the White House Fourth of July festivities in 1994, President Clinton entered to an 1873 version of "Hail to the Chief." That same year, Pollock happened to meet Ken Burns, a graduate of Ann Arbor Pioneer High School and U-M. Both men were at the Baseball Hall of Fame in Cooperstown, New York, doing research. That chance meeting resulted in the Dodworth Saxhorn Band recording the music for Ken Burns's documentary *Baseball*. (Courtesy of the Dodworth Saxhorn Band.)

Books and More Books

Janice Bluestein Longone learned to read before she was five years old, and her love of books led to a lifetime excursion into America's culinary practices. At first, Longone operated the Wine and Food Library, America's oldest antiquarian culinary bookshop, out of her home. Her interest, and that of her husband, Daniel, in the culinary genre culminated with the Janice Bluestein Longone Archive of American Culinary History at U-M. The Longones also founded the Culinary Historians of Ann Arbor. Janice is active with writing, lecturing, teaching, consulting, and providing commentary through various media. She has served as a judge for numerous cookbook and culinary journalism awards, including the James Beard, the Julia Child, and the Tabasco Community Cookbook Award. She also has received several awards, like the Silver Spoon Award, Book Person of the Year at Ann Arbor's 2009 BookFest, and the Amelia Award from the New York Culinary Historians. (Courtesy of Janice Longone.)

Index

AN IMPRINT OF ARCADIA PUBLISHING

Find more books like this at
www.legendarylocals.com

Discover more local and regional history books at
www.arcadiapublishing.com

Consistent with our mission to preserve history on a local
level, this book was printed in South Carolina on American-
made paper and manufactured entirely in the United States.
Products carrying the accredited Forest Stewardship Council
(FSC) label are printed on 100 percent FSC-certified paper.

MADE IN THE USA